童·樂

岩崎知弘經典插畫展

Chihiro Iwasaki Exhibition
Children in the World : Peace and Happiness for All

我希望，當看到這些溫柔圖畫的孩子們長大了的時候，依然會把它們保留在心中的某個地方，所以當他們面對悲傷或絕望的時候，能回想起這些溫暖的繪本而得到平靜。

岩崎知弘，1973 年。

I hope that when the children who have seen these gentle picture books have grown up, they will still keep them somewhere in their hearts, so that when they face sad or desperate times they can be soothed by remembering even small bits of the gentle world depicted in these picture books.

Chihiro Iwasaki, 1973.

目次 Contents

序言

童·樂

岩崎知弘（1918-1974）是日本第一位女性國寶級繪本大師，少年時便開始學習素描和油畫，十八歲開始學習書法。1956年創作的《一個人也能做到》是知弘的第一本繪本作品，1971年以《小鳥來的那一天》獲得波隆那國際兒童圖書展圖像獎，1973年更以《戰火中的孩子》獲得萊比錫國際書展銅牌獎。知弘於1974年因病過世，享年五十五歲。畫家位在東京練馬區的故居及故鄉長野縣安曇野日後成立了知弘美術館，向世人介紹她的藝術成就。

岩崎知弘筆下的兒童形象細膩多姿、觀察細微，因此有「兒童畫家」美稱。知弘終生都以「孩童」作為創作主題，技法上則融合西方水彩畫與東方傳統繪畫，巧妙運用水彩渲染及留白來表現兒童既活潑生動又柔和細膩的形象。由於畫家成長過程經歷過二次世界大戰，體認戰火無情，因此熱愛和平。岩崎知弘創作不懈，持續透過報章雜誌及繪本發表插畫作品，藉由圖像向大眾傳達畫家內心對於孩童的愛與關懷，冀望「讓世界上所有的孩子，都能在和平中過著幸福的日子。」

2018年適逢岩崎知弘百年冥誕，本館特與日本知弘美術館合作，挑選100件從未於海外展出的經典原作，辦理《童·樂—岩崎知弘經典插畫展》，展品包含廣為人知的《窗邊小荳荳》系列插畫作品、經典童話繪本《拇指姑娘》、《戰火中的孩子》以及畫家於40至70年代所創作的多幅鉛筆素描及水彩作品，希望透過岩崎知弘不同時期的系列畫作闡述畫家生命故事並介紹其獨特技法，讓觀眾近距離欣賞畫作並共感畫家對於孩子內心世界的細膩觀察。

本館多年來在引介畢卡索、梵谷、莫內等西方重要藝術家之餘，亦致力擴展臺灣觀眾對新興藝術媒介的視野，陸續展出包括迪士尼與皮克斯等經典動畫藝術。本館此次規劃《童·樂—岩崎知弘經典插畫展》，除介紹岩崎知弘女士的藝術表現與成就外，更希望能喚醒觀眾的赤子之心與對兒童的愛，並體現畫家終生的期盼—讓孩子在安全與充滿幸福的環境中成長。本項展覽能夠順利呈現在國內觀眾眼前，本館衷心感謝知弘美術館的支持及蔚龍藝術有限公司的鼎力協助。

國立歷史博物館代理館長　陳濟民

Preface

Chihiro Iwasaki (1918-1974) was a female master painter and illustrator of Japan. In her youth, she began to learn sketching and oil painting. When she was eighteen, she began to learn calligraphy. The work *I Can Do it All by Myself* of 1956 was her first picture book. *The Pretty Bird* won the Graphic Prize Fiera di Bologna in 1971 while *Children in the Flames of War* won the bronze medal of the Leipzig International Book Fair in 1973. Chihiro passed away at the age of 55 in 1974. Chihiro Art Museum was established on the site of her home in Nerima, Tokyo in 1977 followed by Azumino in 1997, Nagano in memory of her artistic achievement and contribution.

Throughout her artistic career, Chihiro took children as her subject; her portrayal of children is varied and elaborate. Technically, she integrated the Western watercolor painting and Eastern traditional painting to present vivid and soft images of children. Having been through the Second World War, Chihiro experienced its cruelty and devoted herself to peace after Japan lost the war. She worked diligently in artistic creation and published her works in newspapers and picture books. Through her distinctive images, she communicated to the public her love and care of children, hoping to achieve "peace and happiness for all the children of the world".

The year 2018 marks the centennial of Chihiro Iwasaki's birth. To celebrate this occasion, the National Museum of History cooperates with the Chihiro Art Museum to present 100 pieces of her original works *in Chihiro Iwasaki* Exhibition. These works include works from the famous book *Totto-Chan: The Little Girl at the Window*, those from classic fairy tales like *Thumbelina* and *Children in the Flames of War*, and many pencil drawings and watercolor paintings created between 1940s and 1970s. These works of various periods introduce the life story of Chihiro and her distinctive techniques, bringing the audience closer to the artist's close observation of children's hearts and minds.

For many years, besides introducing important Western artists like Picasso, Van Gogh, and Monet, NMH also devotes to extending Taiwanese audience's perspectives on the new art media, organizing exhibitions on Disney and Pixar. In this exhibition, we hope to celebrate the artistic achievement of Chihiro Iwasaki and waken the audience's inner child and love for the children, realizing the artist's ardent wish of giving children a safe and happy environment to grow up. The Museum would like to express heartfelt appreciation for the Chihiro Art Museum and Blue Dragon Art Company for their supports that make the exhibition possible.

Chen Chi Ming, Acting Director of National Museum of History

序言

———————
童·樂——岩崎知弘經典插畫展

祝賀岩崎知弘百歲紀念展

今年適逢岩崎知弘百歲冥誕，在此值得紀念的時刻，能讓臺灣各界欣賞她的紀念展，感覺特別高興。

四十四年前的八月九日，因為收到朋友致贈生日禮物，打算出門購買知弘的繪本當回禮，正當我走出玄關在電梯前等候時，信手打開信箱內的報紙，赫然發現，報載繪本畫家岩崎知弘過世的消息。感覺彷彿是孩子們的守護者離開人世了，霎時淚流不停。為不曾謀面的人離世而流淚，這是我過去不曾有的經驗。

稍後不久，我寫了一封悼念函給家屬，也在這機緣下，我開始到知弘家裡拜訪，並參觀保留她生前樣貌的畫室。隨後，配合知弘美術館的籌建計劃，我也協助向全國各界呼籲參與，這一切都恍如昨日。而知弘美術館也於一九七七年正式揭幕，開館後一段期間，我才得知原來這是全球第一座繪本專門美術館。

在此之前我就曾計劃，將幼年時就讀的巴氏學園撰寫下來，並希望能邀請知弘幫忙作畫，然而她竟然已經離開人世，令我萬分懊惱。而當我將這構想告訴知弘的兒子—松本猛先生，他告訴我知弘的遺作中有很多適合的畫，並一一為我挑選出來，這便是許多臺灣讀者熟悉的《窗邊的小荳荳》。不了解的人，或許會以為是先有故事完稿，知弘閱讀後再依照內容創作。事實上，那是由她的遺作中挑選出適合小荳荳故事的畫作而使用。由此也可看出，知弘對小朋友各種姿態的描寫是多麼豐富。連同我這遭到退學的小女孩在內，她透過畫筆捕捉出小朋友的各種神韻。

知弘美術館內除了知弘的作品，也大量收藏、展示了全球各地畫家的繪本。館藏總計多達二萬七千本，規模居全球之冠，令我同感榮幸。但是這些收列在館裡的畫家作品，他們的國家卻有很多小孩無法閱讀繪本或參觀美術館，甚而連讀書的機會都遭到剝奪。

我的孩童時代，也就是《窗邊的小荳荳》所描寫，在巴氏學園的電車教室上課時，正逢戰爭期間，而知弘也是在這段時間度過她的青春歲月。戰後，知弘深知在那場戰爭中，我們國家帶給亞洲各國人們極大的苦難，而深感痛心。她希望全球的孩子不要再次受到磨難，因此終其一生持續創作不懈。

「孩子啊，真是好可愛」、「別讓孩子哭泣」這是知弘的畫作所要傳達的訊息，衷心期盼，這份訊息也能傳達到臺灣各位的內心深處，繼而化為一股溫柔而強烈的力量。

謹期待岩崎知弘紀念展能帶給各位喜悅。

知弘美術館館長　黑柳徹子
（演員、聯合國兒童基金會親善大使）

Preface

Blessing to the Memorial Exhibition of
Chihiro Iwasaki Centennial

I am thrilled to have the opportunity to exhibit Chihiro Iwasaki's works in Taiwan in the year of her 100th birthday. It means a lot to share her works with people in Taiwan knowing the value of her art.

On August 9th forty-four years ago, I was going to purchase a picture book of Chihiro Iwasaki as a return gift for the birthday present I was given earlier by a friend. I walked to the corridor and waited for the elevator after fetching the newspaper in the mailbox. Opening the newspaper, I learned the news of Chihiro Iwasaki's death and couldn't help myself from being in tears. I felt as if we had lost a dear friend for children. It was the first time I cried for the death of a person I never met.

I wrote a condolence letter to Chihiro Iwasaki's family and was invited to pay visits to her house where her studio remained as it was. When the Chihiro Art Museum was to be established, I advocated for a nation-wide participation, which seems to me as if it happened yesterday. Chihiro Art Museum was inaugurated in 1977, not until it had opened to the public for quite a while did I understand it is the world's first art museum specializing in picture books.

Before all this had happened I had a plan to write down my experience in the Tomoe Gakuen School which I attended as a little girl. I wished to engage Chihiro to illustrate for me. Her death left me in despair, but when I talked about it with Takeshi, her son, he told me there were quite a few works which would match my stories and searched for them. Surprisingly, from her abundant works, I could find a character perfect for me, the dropped-out girl, with various positions and expressions. It turned out to be the book *Totto-Chan: The Little Girl at the Window* that is also very familiar to Taiwanese readers. It looks like the illustrations were created according to the text, but in fact, all the pictures matching the stories were found from Chihiro's works after her death.

The Chihiro Art Museum collects not only her works but also as many as 27 thousand illustrations for books from all over the world. I am honored to say, it is the world 's largest collection. Unfortunately, there are children from the countries of these artists who are not able to read picture books or go to museums, or even go to schools to study.

Just like *Totto-Chan,* my childhood was spent during the war, when I was studying in the classrooms transformed from train wagons. Chihiro was in her youth at that time, and after the war, she acknowledged and pained that our country had caused great agonies to the neighboring countries in Asia.

"Children are so adorable!" "Don't break their hearts!"

These are the messages Chihiro were sending through her paintings. I sincerely expect that her messages will be delivered to the heart of everyone and transferred into the great power of tender love in Taiwan.

Hopefully this Memorial Exhibition will bring pleasure to all.

Tetsuko Kuroyanagi, Director of Chihiro Art Museum
(Actress & UNICEF Goodwill Ambassador)

序言

———

記得多年前,第一次翻開《窗邊的小荳荳》,跟著生動的文字、溫暖的插畫,一起展開前往巴氏學園的學習之旅。如同國內兒童文學作家幸佳慧給予本書的評價,「現在,回頭看更是清晰,這本書對我的意義,遠遠超過『撫慰心靈的藝文小品』之效,事實上,它是點燃我與很多人成為教育異議者與改革者的火種,那是一顆既溫暖又溫柔的經典火種。」作者黑柳徹子女士是第一位擔任聯合國兒童親善大使的亞洲人士,長期致力於關懷全球弱勢孩童,而插畫繪者則是曾獲得波隆納國際兒童圖書展圖像獎,和萊比錫國際書展銅牌獎等多項榮譽,日本第一位女性的國寶級繪本大師岩崎知弘女士。

相信許多臺灣讀者也跟我一樣,是從《窗邊的小荳荳》這本書開始接觸岩崎知弘的繪畫。這本書從 1981 年出版後,銷售超過千萬冊,成為日本出版史上最暢銷的書籍,被譯成 35 國語言,堪稱世代必讀的經典名著。書中的插畫繪者岩崎知弘女士享有「兒童畫家」的美名,畫筆下的兒童形象純真,技法上則融合西方水彩筆觸與東方傳統繪畫,巧妙運用渲染及留白來表現兒童既活潑生動又柔和細膩的表情,感動全球千萬讀者。

為紀念岩崎知弘,於其東京的故居及故鄉長野縣,成立了知弘美術館,向世人介紹她的藝術成就。知弘美術館因而成為全球各地為數不多、致力於單一一位兒童插畫藝術家作品的美術館先鋒,而其國際收藏更是全世界最豐富的,典藏來自 34 個國家的 206 位插畫家近 17,600 件作品,涵蓋曾榮獲凱迪克大獎、安徒生插畫大獎和布拉迪斯插畫雙年展大獎等國際大獎的知名插畫家。希望透過國際收藏的多樣性,讓世人能欣賞到全球傑出插畫家的原作,並藉此對世界插畫藝術有全面的認識和瞭解。

本人曾多次拜訪位於東京的知弘美術館,美術館裡許多貼心的設施,讓參觀者可以輕鬆地欣賞岩崎知弘的作品,戶外規畫「知弘的庭院」,種植作品中的花花草草。社區的長者、父母、小孩經常來美術館,一起共度美好時光,是一個提供心靈休憩的美術館。以溫馨氛圍打造兒童藝術中心,輕柔地訴說著知弘對世界和平的真誠願望,值得臺灣的兒童圖書機構借鏡。

今年適逢岩崎知弘(1918～1974)的百歲冥誕,很開心能夠將這位國際重量級的繪本藝術家介紹給臺灣觀眾,也是蔚龍藝術於 2013 年舉辦「奇幻旅程莉絲白・茨威格插畫展」、2014 年「波隆納插畫大展」、2015 年「色彩魔法師 - 柯薇塔的繪本王國」、2016 年「國際安徒生插畫大獎 50 周年展」以及 2017「波隆納插畫 50 周年展」的書,持續引進國際插畫大師作品以饗國內觀眾,歡迎您帶著赤子之心,與我們一起來欣賞《童・樂─岩崎知弘經典插畫展》!

<div align="right">蔚龍藝術有限公司總經理　王玉齡</div>

Preface

The first time I opened the *TOTTO-CHAN: The Little Girl at the Window* many years ago I was brought to a journey with the Tomoe Gakuen School through the lively words and heart-warming illustrations. The author, Ms. Tetsuko Kuroyanagi, is the first Goodwill Ambassador of the UNICEF from Asia, she devotes herself in the welfare of underprivileged children all over the world. The illustrator was the winner of the Bologna Children's Book Fair Graphic Award and the Copper Medal of the Leipziger Buchmesse, Chihiro Iwasaki , a female master illustrator in Japan. Taiwanese writer of children's literature Arlene Hsing commented on this book, "Looking back, it is more clear how this book meant to me. Its influence is far beyond tons of self-improvement publications together. In fact, it ignited the fire of many dissidents and reformers of education, including me. It is a firestarter tenderly giving heat."

I believe there are many readers in Taiwan, like me, got to know Chihiro Iwasaki's art through *TOTTO-CHAN*. Since published, this book has sold more than ten million copies in 36 languages. It is the most popular publication in the history of Japanese publishing industry, and is deemed a classic work for generations. Chihiro Iwasaki's portraits of children were highly praised, the images of ingenious children were represented with a style mixed of western watercolor painting and traditional eastern ink painting. The subtle color blending and carefully preserved white areas successfully outline the delicate expressions of each character, touching so many readers all over the world.

In memory of Chihiro Iwasaki, the Chihiro Art Museum Tokyo was established on the site of her house, and later another museum was set up in her spiritual hometown in Nagano Prefecture. In addition to presenting Chihiro Iwasaki's art, Chihiro Art Museum has the richest collection of over 17,600 works by 206 illustrators from 34 countries. These authors include recipients of the the Caldecott Medal, the Hans Christian Andersen Award for Illustration, and the Biennial of Illustrations Bratislava Prize. The great diversity of the collection brings visitors to the original works by illustrators from Europe, Northern and Southern Americas, Asia, Africa and Oceania. Visitors are able to see the world's development of illustration comprehensively.

I've visited the Chihiro Art Museum in Tokyo many times and noticed many considerably designed details that help visitors to appreciate Chihiro Iwasaki's works easily. Outside the building, the Chihiro's Garden is planted with a variety of plants and flowers, attracting elderly, children and their parents from the surrounding communities to spend time here. It's a museum people can find peace of mind. This museum tenderly passes on Chihiro's wishes for children— world peace. The arrangement of this museum can be a model for children's libraries in Taiwan.

Over these years Blue Dragon Art has staged *The World of Imagination—Lisbeth Zwerger's Original Illustration Exhibition* in 2013, *Bologna Illustrators Exhibition* in 2014, Czech illustrator *Květa Pacovská* in 2015, *Hans Christian Andersen Awards for Illustration 50th Anniversary Exhibition* in 2016, and *Bologna Illustration* 50th *Anniversary Exhibition* in 2017. In 2018, marking the centennial of Chihiro Iwasaki's(1918~1974) birth, I am very glad to introduce this Japanese master illustrator to Taiwan's audience. It is a continuation of our promotion of illustrations. In 2018, we invite you to the *Children in the World: Peace and Happiness for All* to rediscover the child in you.

Wang Yuling, Blue Dragon Art Company

展覽介紹

童·樂——岩崎知弘經典插畫展

2018 年為日本插畫家岩崎知弘（1918-1974）的生誕百年紀念年。岩崎知弘的畫作以童書為主軸，五十五年的生涯當中留下了近萬件作品。本次國立歷史博物館特別從知弘美術館（東京·安曇野）收藏的作品中選出百件原畫，以及岩崎知弘生前使用的個人用品等，分為六個主題展區展出。在日本以外的地方舉辦這樣大規模的原畫展，本展算是首開記錄之先。

岩崎知弘非常喜歡小孩，她曾經說過：「對我而言，不管是身上沾滿泥巴、或是衣衫多麼襤褸的孩子，看起來都是胸懷夢想的美麗孩子。」她筆下所描繪的許許多多的孩子，半個多世紀以來，深受各個世代的日本人喜愛。在父母親讀給孩子聽的繪本裡、學校的教科書、街頭的海報、裝飾房間的月曆、親友餽贈的明信片裡…許多日本人是在不知不覺中邂逅岩崎知弘的畫作。

包括臺灣在內，很多國家的朋友是因為《窗邊的小荳荳》這本書開始接觸岩崎知弘的繪畫。《窗邊的小荳荳》是作者黑柳徹子就讀「巴氏學園」的小學時代自傳回憶。其實在作者執筆、出版該書之前，岩崎知弘已經過世，若當時岩崎知弘還在世，應該也會和眾多讀者一樣，看到在小林校長和理解童心的大人們守護之下，自由奔放的小荳荳和其他精彩可愛的小朋友們，手牽著手一同學習、成長，而深受感動。黑柳徹子在《窗邊的小荳荳》的後記裡寫道：

「岩崎知弘真是畫小孩的天才。我想世界上再也沒有其他畫家能像她這樣，把孩子們畫得如此靈活傳神。只要是小孩子，不管擺的是什麼樣的姿勢，是六個月大或九個月大的嬰兒，岩崎知弘都能畫得出其中的差異。我先前一直夢想，寫這本巴氏學園的書時，希望能使用岩崎知弘的畫作，她是那麼愛孩子、那麼樂意為孩子的幸福祈禱祝福。現在我的夢想實現了，還有什麼事情能比這個更快樂呢？另外，因為我的文章和岩崎知弘的繪畫搭配的天衣無縫，有讀者以為『是岩崎知弘過世之前，先幫妳畫了一些嗎？』換言之，岩崎知弘的畫作，就是這麼有孩子的模樣，而且是各種不同孩子的不同模樣。」

岩崎知弘畫作裡的孩子們，通常置身在四季各式花卉與情境中。她的水彩畫作用色豐富，並且巧妙地運用水來表現顏色的濃淡渲染效果，這或許可以歸功於她年輕時學過在中國、日本甚為流行的「書法」，因而擅長運筆以及掌握墨與水之間的關係。人們說她即使沒有模特兒，也能畫出小孩子的任何一種姿勢模樣，這應該是鑽研無數素描才累積得來的功力。在她畫作裡的孩子眼眸是圓潤的、嘴角是輕閉的，這個表情特徵不只是可愛而已，也透出一股力道，讓觀畫者感受到孩子的尊嚴。

岩崎知弘過世四十多年了。世界快速改變著，因為技術的進步，許多當時做不到的事情，現在都已經成為可能。岩崎知弘說過：「經濟不斷成長，相對地，人心恐怕會漸漸失去豐盈從容。年輕人多半不會注意這個，不過我很早就發現到這一點，也希望大家多思考一下什麼是豐盈和從容」。期盼透過本次展覽，無論是孩童或大人，能夠一起享受岩崎知弘的作品世界，並且攜手朝向和平美好的未來邁進。

Exhibition Statement

Japanese artist Chihiro Iwasaki (1918-1974) was born 100 years ago. Her paintings mostly appear in children's books. She left nearly 10,000 pieces of works behind her. National Museum of History selects 100 original paintings, as well as her favorite tools, from Chihiro Art Museum collection, and exhibits in six sections. This is the first major Chihiro Iwasaki exhibition of original works overseas.

Iwasaki loved children. "To me, every child, even if muddy or ragged, is beautiful and full of dreams," she once said. Over the past 50 years, Japanese readers across generations love children in her illustrations, available in children's books, textbooks, posters, calendars, and postcards. Many people in Japan unconsciously encounter her works over the years.

Many readers around the world, including those in Taiwan, are exposed to Iwasaki's illustrations from the book *Totto-Chan: The Little Girl at the Window,* a biography by Tetsuko Kuroyanagi about her primary school memories. In fact, Iwasaki passed away before the book was written and published. If she were alive, she would be moved, as many readers are, by Totto-Chan, other children, the principal, and adults in the story. In the afterword, the author wrote:

"Chihiro Iwasaki is such a genius to depict children. I don't think any other artists in the world can draw vivid and authentic children as such. In her works, you can tell the difference even between six months old and nine months old, no matter what poses these children are. I've always dreamed about using Iwasaki's illustrations in this book. She loves children so much, and she is so willing to pray and give blessings to children. What can be happier than fulfilling my dream? As my story and Iwasaki's works are so well coordinated, some readers assume these works are done in advance particularly for me. This shows her works really portray different aspects of many children."

Children in Iwasaki's illustrations are often surrounded by flowers and seasonal scenarios. Her paintings are colorful, and she uses water and ink skillfully to demonstrate various shades. It may attribute to her calligraphy experiences, which were popular in Japan and China in her youth. Even without models, people say, Iwasaki could describe all kinds of poses and gestures of children. This skill was developed after countless sketches and practices. Features like round eyes and loosely closed lips in these figures are not only adorable, but also representative of power and dignity.

Chihiro Iwasaki passed away more than 40 years ago. The world has come a long way. Many impossible ideas become possible due to technology advances. "Economy continues to grow," she once said, "but our minds gradually lose essence and pace. Young people mostly do not pay attention to it, but I've noticed this change from early one. I hope everyone can think about essence and pace." We hope every visitor, young or old, will be able to enjoy her world and works in this exhibition, and move towards a peaceful and beautiful future.

I

岩崎知弘的生命旅程

Life of Chihiro Iwasaki

岩崎知弘的生命旅程

1918 年，岩崎知弘出生於日本福井縣的一個雙薪之家，於三姊妹中排行老大，成長於東京。岩崎知弘個性活潑，擅長繪畫與運動。

因家裡相當重視文化素養，十四歲時進入東京美術學校（現為東京藝術大學）教授－畫家岡田三郎助的私塾，學習油畫與素描，展露出繪畫方面的才華。雖然領取了女子美術學校的入學簡章，但是當時日本還處在封建式家族制度下，岩崎知弘只好放棄了畫家之路。由於日本參戰，岩崎知弘的父母親遵循國策，她也跟著被捲入戰爭的漩渦。

1945 年日本戰敗，岩崎知弘身處價值觀大幅翻轉的社會中，開始認真思考今後應該如何生活。為求自立更生，她擔任報社記者，同時努力學習希望成為畫家。她加入由畫家丸木位里與丸木俊夫妻主導的素描畫會，在丸木俊老師身上學到了「要為自己所畫的每一條線負責」。在成為印刷美術畫家後逐漸嶄露頭角之際，岩崎知弘結婚生子，日日凝視著愛子成長的身影和寫生，淬鍊出隨手即可畫出所有孩童姿態的素描功力。在 1950 至 70 年代，日本從戰後復興，伴隨著經濟的發展，童書出版業蓬勃興起，岩崎知弘也以童書為主軸，活躍在畫家的世界裡。

本章將介紹岩崎知弘從初期到晚年的素描、寫生作品，以及一些她所喜愛的生活用品及照片，帶領您瞭解岩崎知弘的生命旅程。

Life of Chihiro Iwasaki

Chihiro Iwasaki was born before two sisters in 1918 to working parents in Fukui Prefecture, Japan. Raised in Tokyo, her family education focuses on cultural development. Chihiro was very active and enthusiastic to painting and sports.

At age 14, she started to learn oil painting and sketch from Tokyo Art School (now Tokyo University of the Arts) professor and painter Saburosuke Okada. Even though she took admission information from Joshibi College of Art, Chihiro was forced to give up painting career due to patriarchal family system. The family was later impacted by the Second World War.

After Japan surrendered in 1945, the world around Chihiro started to shift. She started to think seriously about career and life. While being a newspaper journalist, she continued her painting aspiration. Chihiro joined the sketching group led by Iri and Toshi Maruki. She learned from Toshi Maruki "to be responsible for every drawn line". Around the time she demonstrated artistic talents in public, Chihiro got married and gave birth to her son. Her sketches during this period began to portray children in variety. From 1950s to 1970s, Japan resurrected from the war and boosted its economy. Children's book publishing prospered, and Chihiro became active as a children's book illustrator.

This section introduces her sketches and works, along with her photos and utensils, to represent her life.

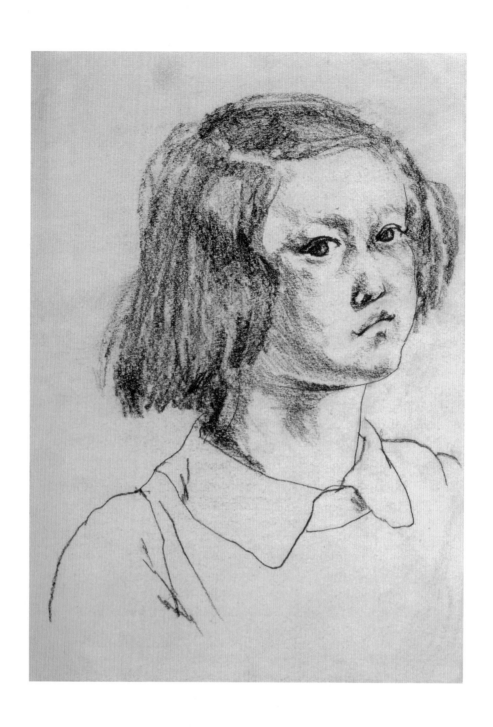

自畫像（約 30 歲）
Self-Portrait (Around Age 30)

鉛筆、紙
Pencil on Paper
256 × 182mm │ Late 1940s

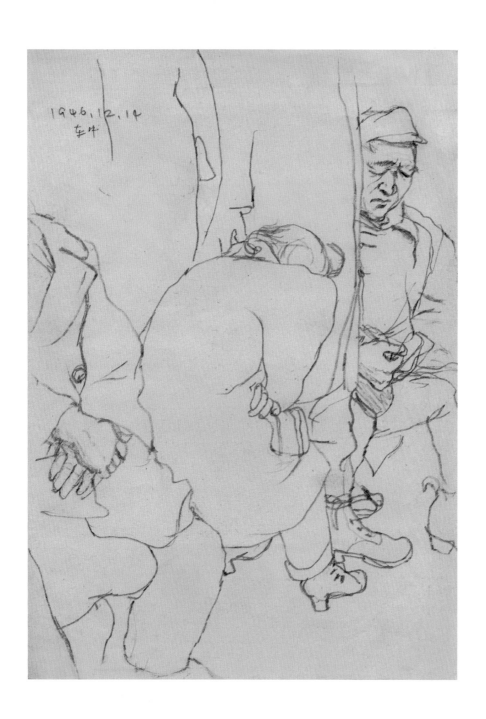

火車上的乘客
Train Passengers

鉛筆、紙
Pencil on Paper
296 × 209mm ｜ 1946.12.14

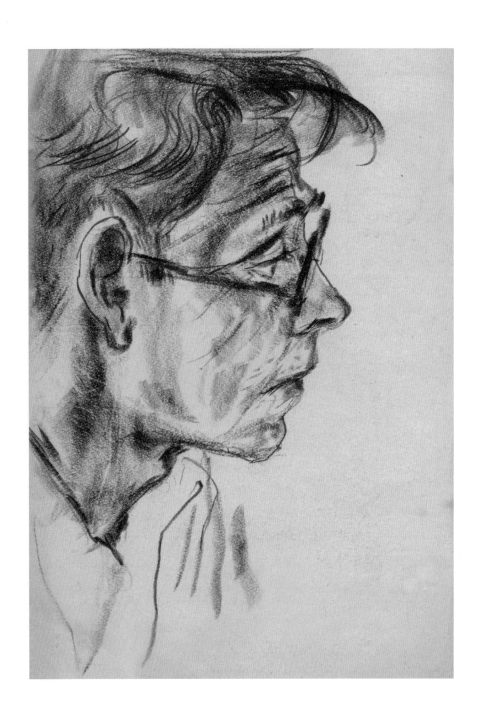

井手則雄畫像
Portrait of Norio Ide

炭精筆、紙
Conté on Paper
296 × 206mm ｜ 1947

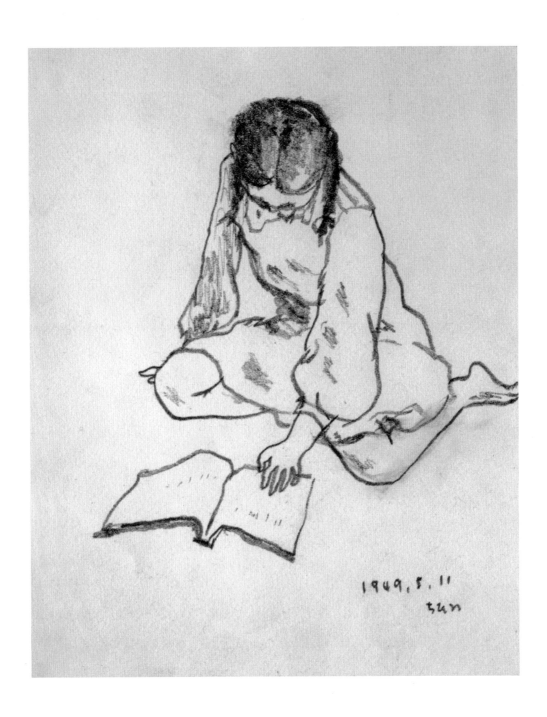

悠閒閱讀中的女孩
Girl Relaxing While Reading a Book

鉛筆、紙
Pencil on Paper
174 × 139mm │ 1949.05.11

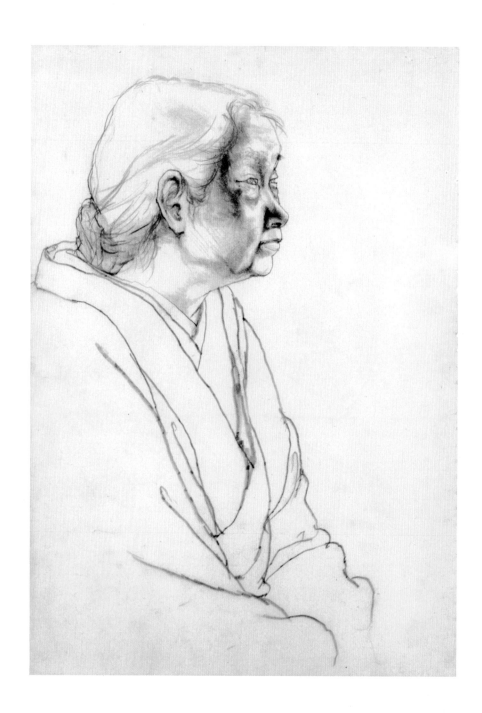

老婦人畫像
Portrait of an Old Woman

鉛筆、紙
Pencil on Paper
362 × 260mm ∣ 1952

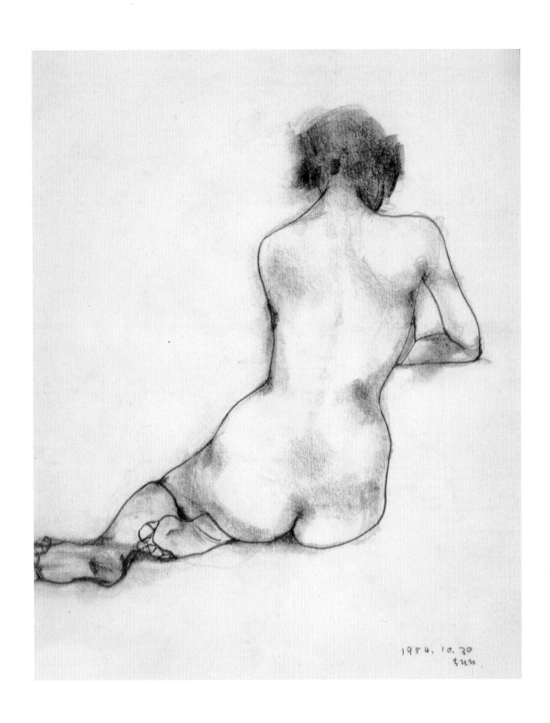

裸女
Nude Woman

鉛筆、炭精筆、紙
Pencil, Conté on Paper
357 × 251mm ｜ 1954.10.30

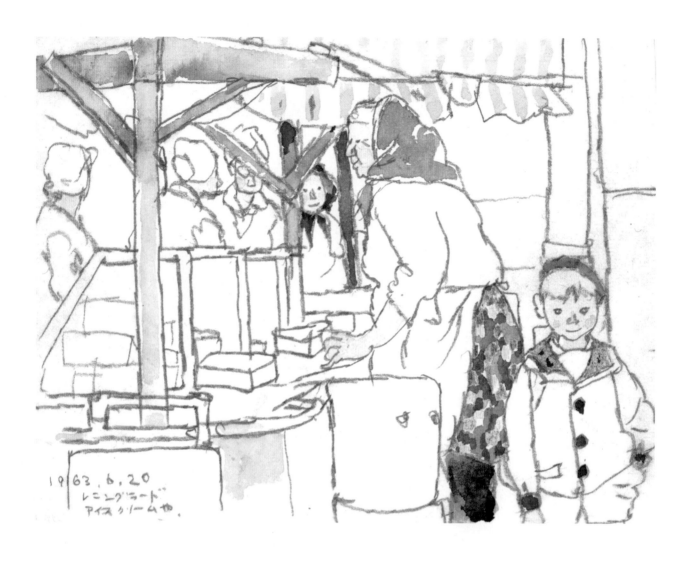

列寧格勒的冰淇淋攤
Ice Cream Stand in Leningrad

鉛筆、水彩、紙
Pencil, Watercolor on Paper
152 × 200mm │ 1963.06.20

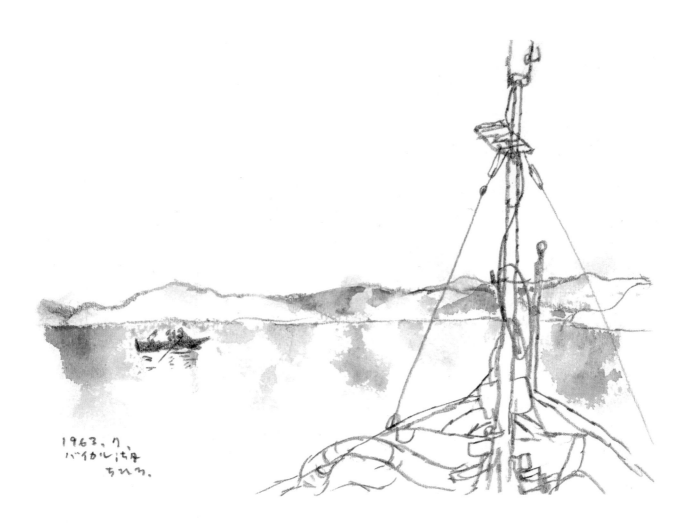

貝加爾湖
Lake Baikal

鉛筆、水彩、紙
Pencil, Watercolor on Paper
145 × 204mm　|　1963.07

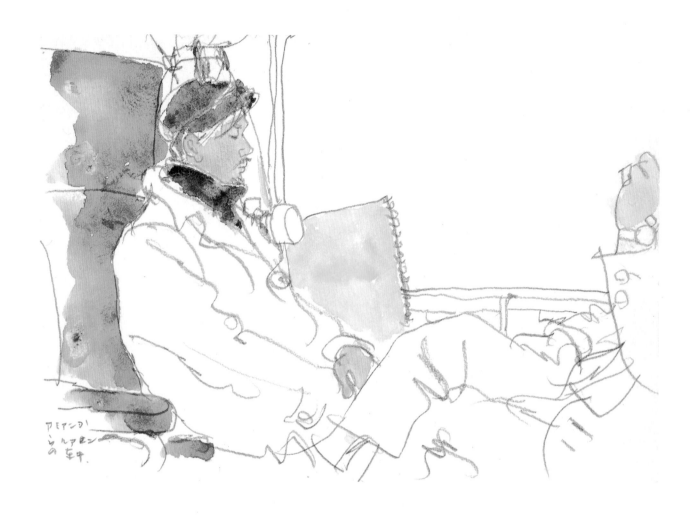

從亞眠到盧昂的火車上
In the Train from Amiens to Rouen

鉛筆、水彩、紙
Pencil, Watercolor on Paper
160 × 235mm ｜ 1966.04

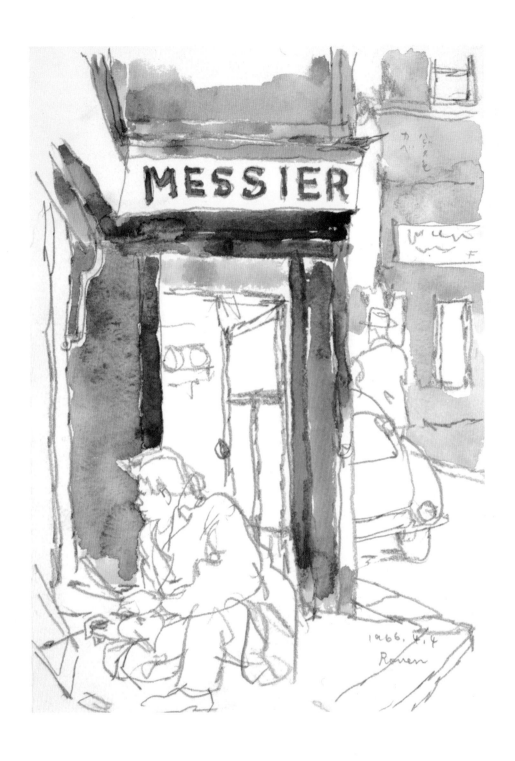

速寫在盧昂市街角的男子
A Man Drawing on a Street Corner, Rouen

鉛筆、水彩、紙
Pencil, Watercolor on Paper
235 × 160mm │ 1966.04.04

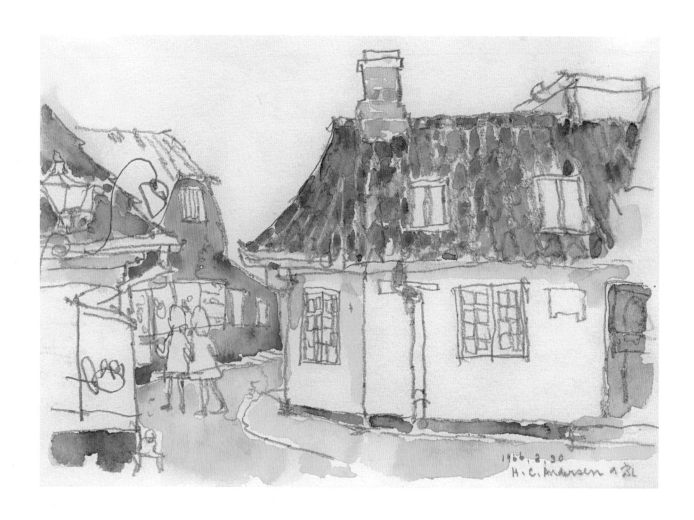

丹麥歐登塞安徒生之家
The Andersen's Home, Odense

鉛筆、水彩、紙
Pencil, Watercolor on Paper
160 × 235mm ｜ 1966.03.30

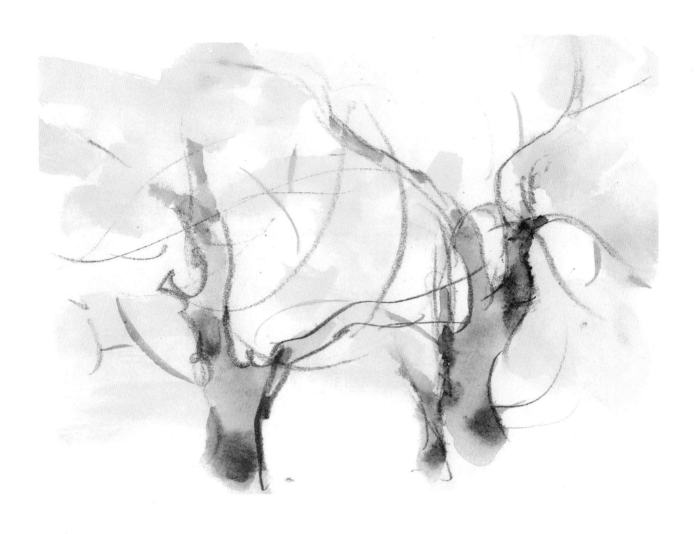

長谷寺的櫻桃樹
Cherry Trees at Hase Temple

鉛筆、水彩、紙
Pencil, Watercolor on Paper
181 × 245mm ｜ 1971.04.03

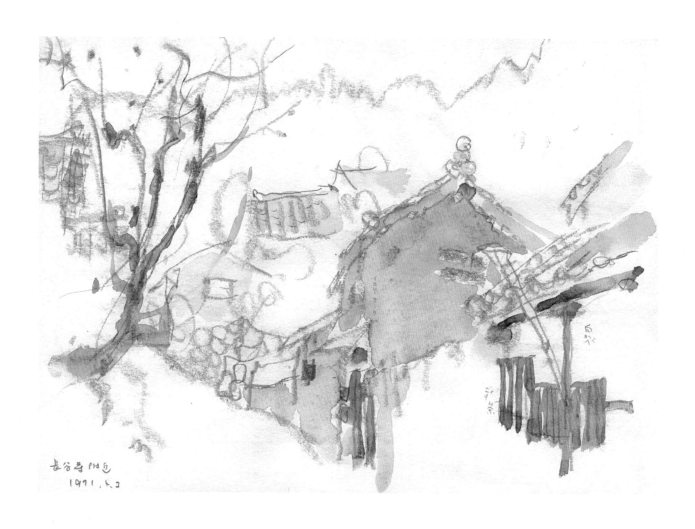

長谷寺附近
Near the Hase Temple

鉛筆、水彩、紙
Pencil, Watercolor on Paper
181 × 244mm │ 1971.04.03

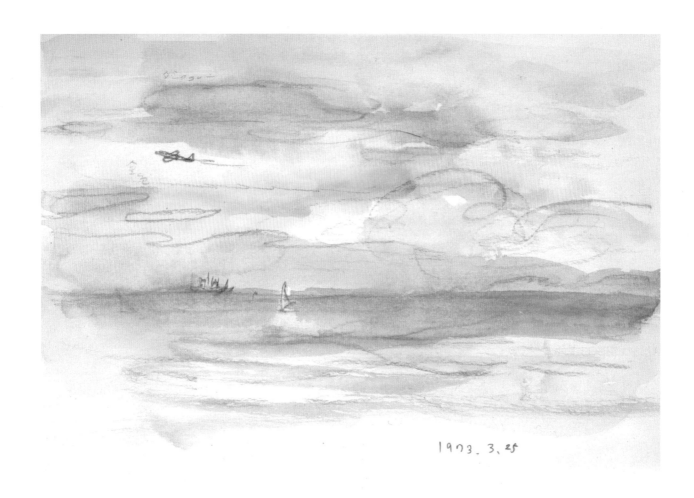

1973. 3. 25

日落威基基海
Sea at Sunset, Waikiki

鉛筆、水彩、紙
Pencil, Watercolor on Paper
182 × 262mm │ 1973.03.25

知弘的用品
Belongings of Chihiro

知弘鍾愛的用品
照相機、旅途中的信函
Objects Always Accompanied Chihiro
Cameras, Letters During Her Trips

1966 年，知弘陪伴母親文江，和畫家好友一起同遊歐洲，歷時近一個月，期間遍訪倫敦、德國、丹麥等地。

在歐洲之旅的照相簿裡，也留有知弘拿著 MAMIA 相機拍照的身影。

In 1966, Chihiro and her mother Fumie, and some artist friends traveled to Europe together for a month. They visited U.K., Germany and Denmark, among other countries.

In the album of their trip in Europe, Chihiro's profile of taking a camera could be found.

攜帶型水彩套具
Portable Watercolor Painting Set

旅行所到之處，知弘會向旅舍另外借一張繪畫專用的桌子。將桌子放在窗邊光線明亮處，以煙灰缸取代洗筆盒、放有旅行用固體水彩的調色盤，將必要用具依序排放在桌上後，知弘就打開素描本，將當天所畫的素描添上色彩。

Wherever she traveled, Chihiro would borrow a desk for her drawing from the hotel. She would put the desk next to windows to catch sunlight.

The ashtray was used to carry water for brush washing, and a palette from the portable set was to mix solid watercolor paints among other tools arrayed on the desk.

Then Chihiro opened her sketchbook and started coloring the paintings she had done earlier that day.

知弘的畫桌
文房用品
Chihiro's Drawing Desk
Stationeries

知弘繪畫創作時，除了水彩，鉛筆和鋼筆也是她愛用的道具。而左撇子的知弘，對於剪刀也特別講究使用的舒適性。

當時畫家的著作權仍然還不受重視，繪本的原畫等往往不會再歸還給畫家，因此知弘在交付出版社作品時，會特別蓋上「請歸還原畫」的橡皮印。

In addition to watercolors, Chihiro also used pencils and fountain pens a lot in her painting. A left-hander, Chihiro cared about the comfort of using scissors especially.

It was a time that artists' right were not completely guaranteed, so on each painting Chihiro put a rubber stamp saying "Please return the original piece to the artist."

知弘鍾愛的用品
絲巾、項鍊、口紅、小鏡子
Chihiro's Personal Objects
Scarfs, Necklaces, Lipsticks and Mirrors

知弘平日不愛化妝，髮型也是自學生時代以來始終如一，因此絲巾和帽子對她而言，正是時尚妝點配件，而從可愛的小碎花絲巾和小鏡子中，顯露出知弘的品味。

Chihiro did not wear makeup very much, and she maintained the hairstyle of a student all her lifetime. Scarfs and hats were her interest of fashion. And from the scarf with patterns of small flowers and the small mirrors she used, the audience can feel a flavor of her taste.

知弘於家中進行創作，1960 年
Chihiro, Sketching in Her House, 1960

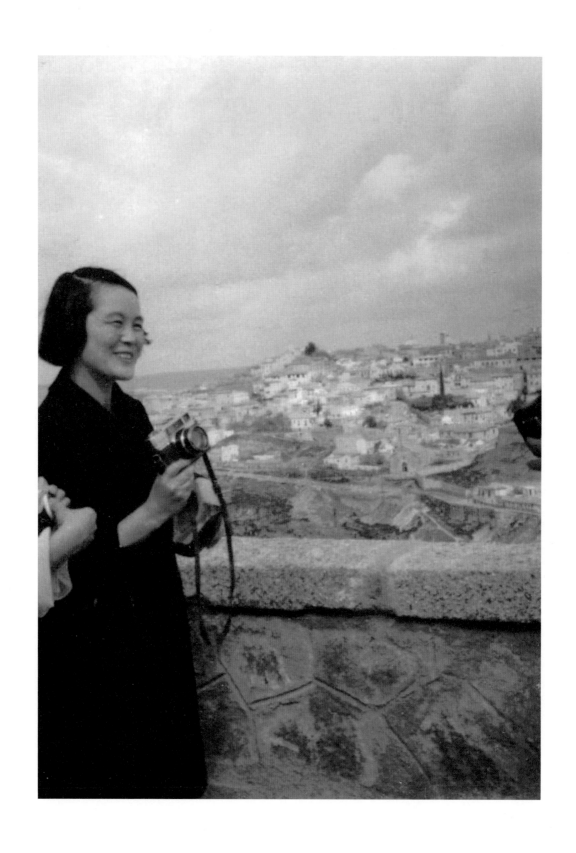

攝於西班牙托雷多，1966 年
Toledo, Spain, 1966

II

孩子與四季更迭

Children in the Changing Seasons

孩子與四季更迭

「春」— 陽光日漸溫暖，庭院中各色花朵開始綻放，山野草木發芽，風景明媚，色彩豐盈。

「夏」— 日光燦爛，孩子們在海邊、在山野遊玩，肌膚曬成小麥顏色，閃耀著生命的光輝。

「秋」— 屬於秋天的花朵盛開，迎來果實熟成的季節。紅色、黃色染上樹梢，葉片隨風飄舞，見慣了的景致忽然起了變化。

「冬」— 冰冷的雪花飛舞中，孩子們的眼睛依舊閃亮，穿戴起色彩繽紛的毛衣和帽子，玩得不亦樂乎。

日本的春夏秋冬四季分明，岩崎知弘擅長表現孩子們在四季不同情境中的各種姿態樣貌。她描繪季節風情時，多半不畫眼前當下所見的風景，而是以象徵季節的花、樹葉、貝殼等題材，配合孩子的身影自由奔放地進行構圖。

此外，她運用水彩暈染的效果，並在畫面大量留白，為觀畫者預留自由想像的空間。不作多餘的描寫，溫柔地喚醒觀畫者的想像力，使之感受到風、光與溫度，這樣的表現手法，與將季語融入俳句的世界有著異曲同工之妙。當觀畫者把畫作裡的孩子和自己的影像重疊在一起時，那一幅畫會帶領你重溫孩提時光，也回想起當時的種種悸動。

Children in the Changing Seasons

Spring: Warm sunshine lights up colorful blossoms in the garden. Sprouts and new branches decorate hills and mountains.

Summer: Children enjoy their time in mountain or ocean under daylight. Their skins are tanned and full of life.

Autumn: Seasonal flowers arrive with harvests and fruits. Leaves are dyed in red and yellow, and dancing in the breeze. Changes suddenly emerge in accustomed scenery.

Winter: Children's eyes sparkle amid freezing wind and flying snowflakes. They put on colorful sweaters and hats and have a great time.

Each season in Japan demonstrates different characters. Chihiro was known for portraying children in various seasonal scenarios. When she described seasons, she seldom recorded scenes in front of her. Instead, she utilized symbolic materials, such as flowers, leaves, and shells, to compose with all kinds of children in her works. She took advantage of watercolor effects, and left white spaces for reflection. Her works reduced components to the minimum, and skillfully triggered our imaginations and senses to wind, light, or temperature. These expressions are poetic. When viewers project themselves on these children, these works may transport you back to childhood, and recollect various emotions and memories.

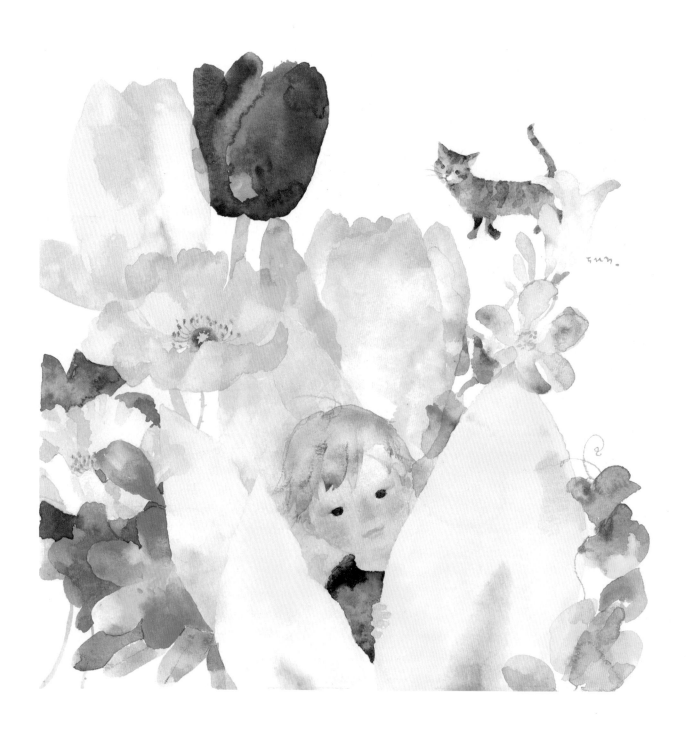

鬱金香叢中的男孩
Boy among Tulips

鉛筆、水彩、紙
Pencil, Watercolor on Paper
318 × 318mm ｜ 1965

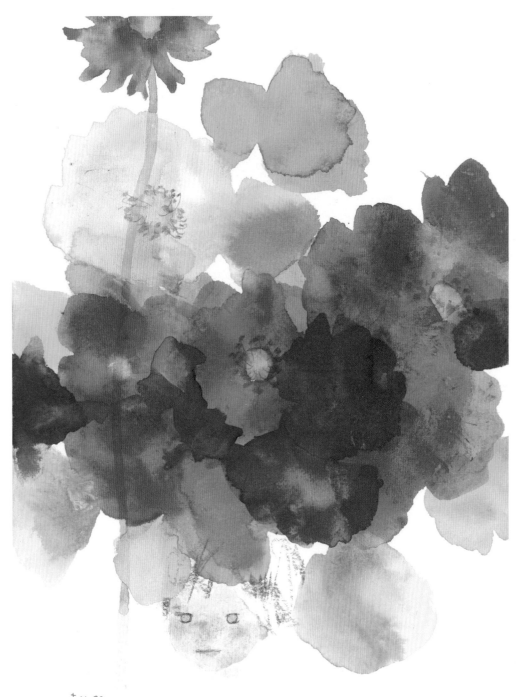

罌粟花與孩子
Poppies and a Child

鉛筆、水彩、紙
Pencil, Watercolor on Paper
595 × 210mm ｜ 1969

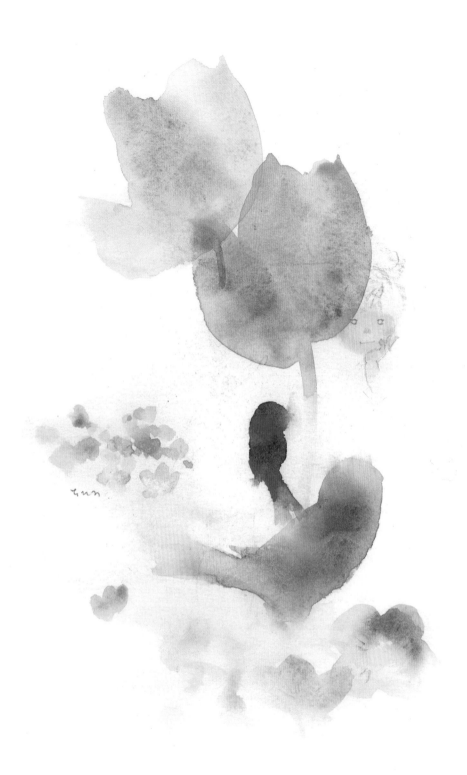

藍色的鳥、花、以及孩子
Blue Fowers, Birds and Child

鉛筆、水彩、紙
Pencil, Watercolor on Paper
359 × 241mm ｜ 1972

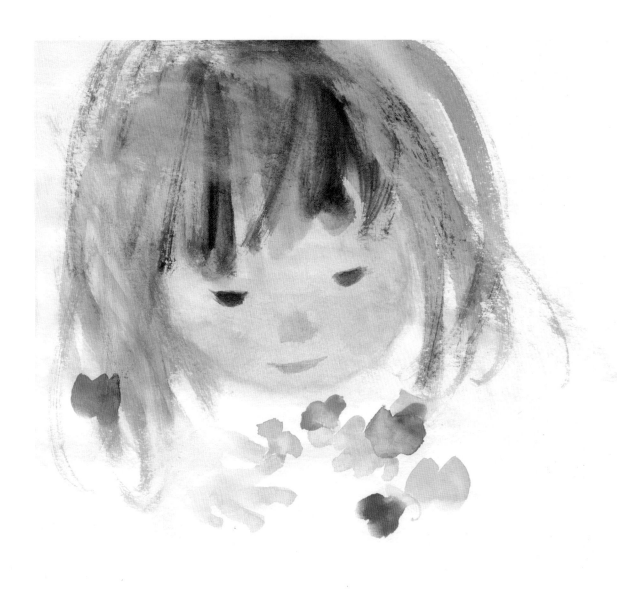

女孩與香豌豆花
Girl and Sweetpeas

水彩、紙
Watercolor on Paper
358 × 326mm ｜ 1973

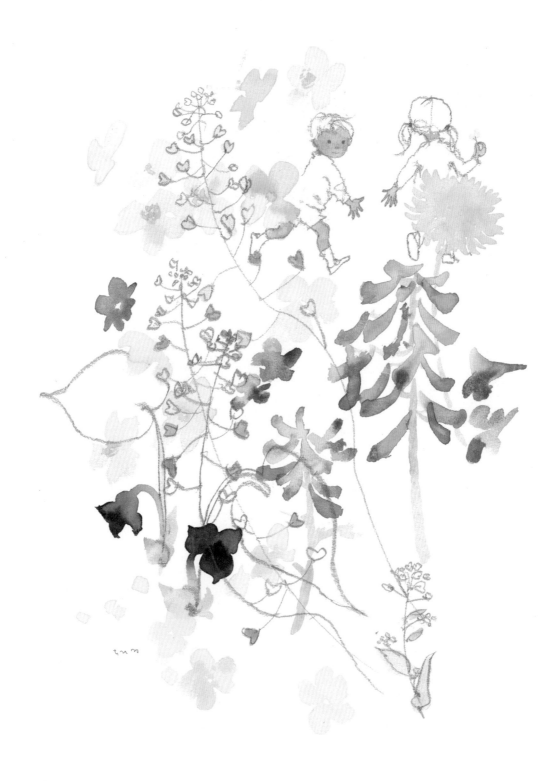

孩童們與春天的花朵
Children and Spring Flowers

鉛筆、水彩、紙
Pencil, Watercolor on Paper
285 × 202mm ｜ 1970

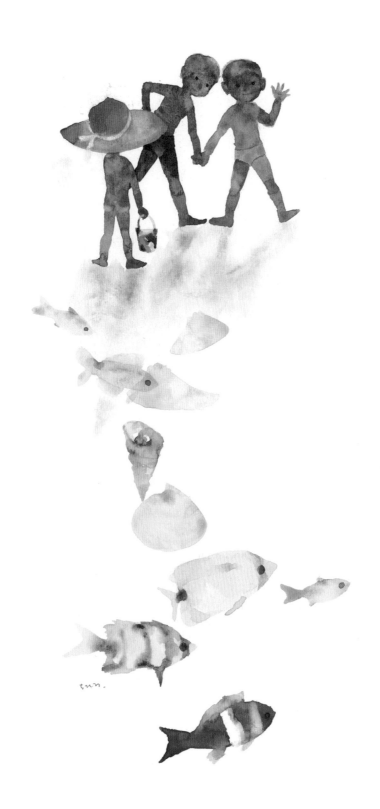

魚與曬黑的孩子們
Fish and Suntanned Children

水彩、紙
Watercolor on Paper
455 × 282mm │ 1969

小男孩拿著貝殼靠近耳邊
Boy Holding a Shell to His Ear

鉛筆、水彩、紙
Pencil, Watercolor on Paper
385 × 305mm ｜ 1970

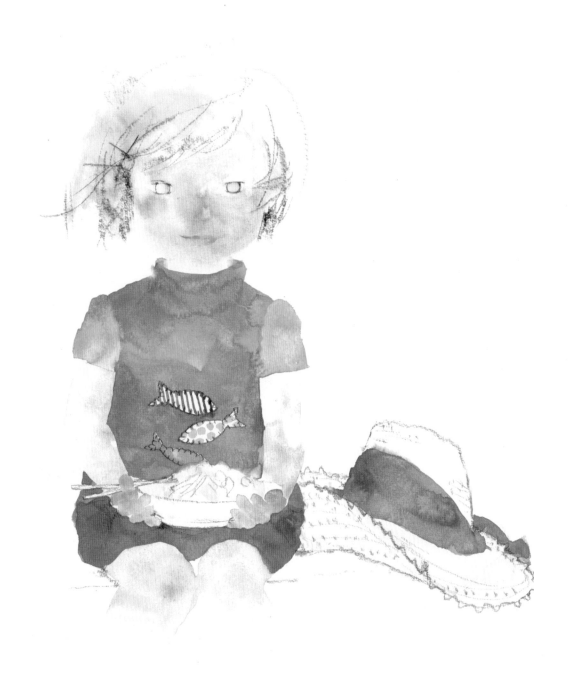

穿橘色洋裝的女孩與魚
Girl in Orange Dress with Fish

鉛筆、水彩、紙
Pencil, Watercolor on Paper
482 × 358mm ｜ Late 1960s

海邊的向日葵、女孩與小狗
Sunflowers, Girl, and Her Puppy at the Shore

水彩、紙
Watercolor on Paper
386 × 545mm ｜ 1973

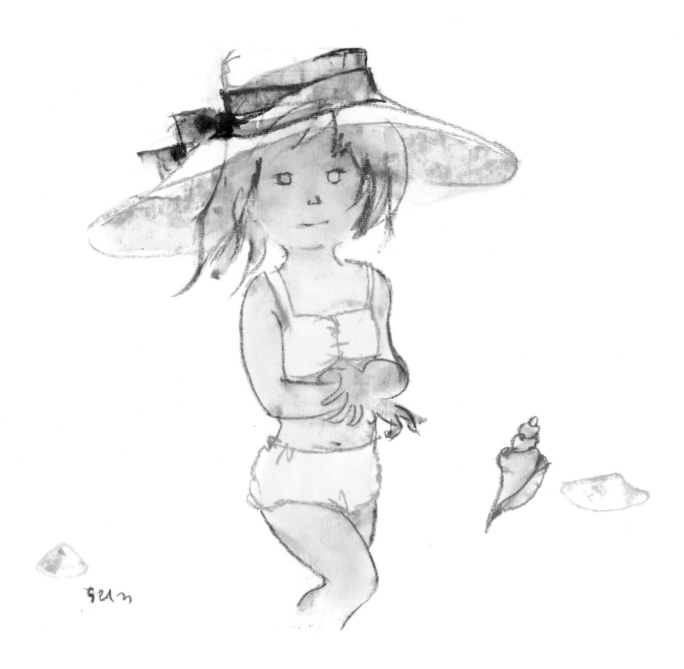

穿比基尼的女孩
Girl in a Bikini

粉彩、紙
Pastel on Paper
500 × 649mm ｜ 1970

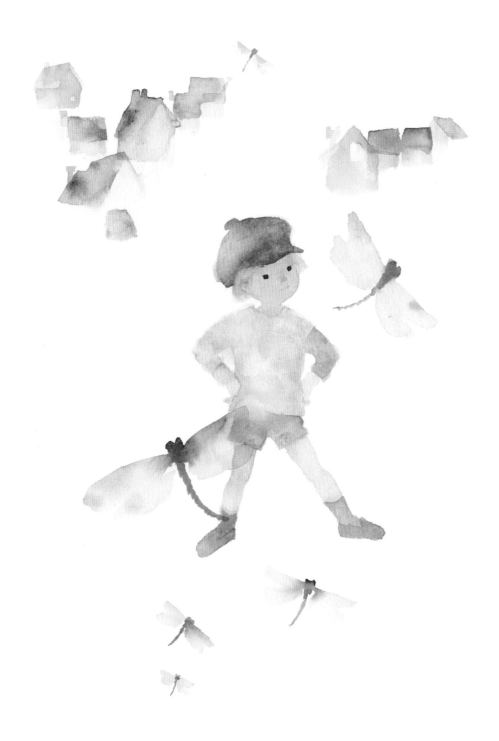

紅蜻蜓與男孩
Red Dragonflies and Boy

鉛筆、水彩、紙
Pencil, Watercolor on Paper
483 × 358mm ｜ 1971

女孩與柿子
Girl and Persimmons

鉛筆、水彩、紙
Pencil, Watercolor on Paper
242 × 180mm ｜ 1972

秋天草堆中的女孩
Girl Among Autumn Grass

鉛筆、水彩、紙
Pencil, Watercolor on Paper
484 × 361mm ｜ 1969

男孩與橡樹果
Boy and Acorns

水彩、紙
Watercolor on Paper
359 × 300mm ｜ 1972

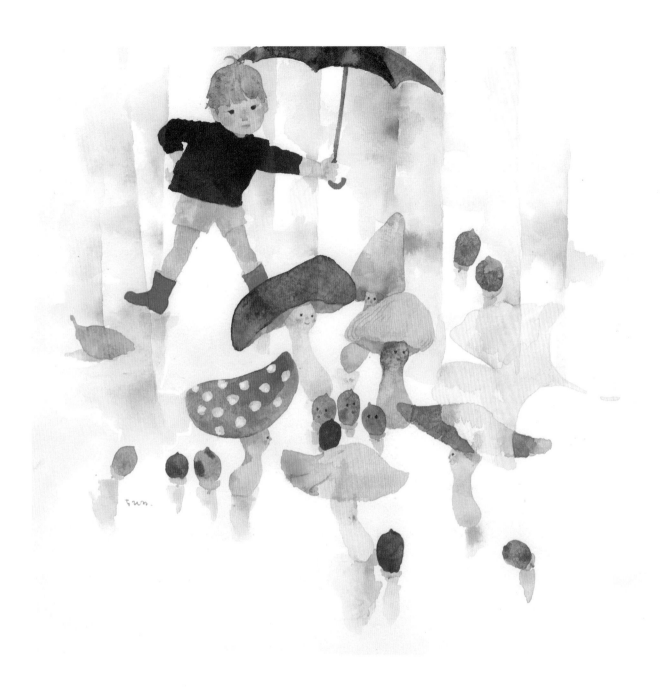

蘑菇與撐著傘的男孩
Mushrooms and Boy with Umbrella

鉛筆、水彩、紙
Pencil, Watercolor on Paper
288 × 292mm ｜ 1966

暖爐與兩個孩子
Stove and Two Children

鉛筆、水彩、紙
Pencil, Watercolor on Paper
226 × 348mm ｜ Late 1960's

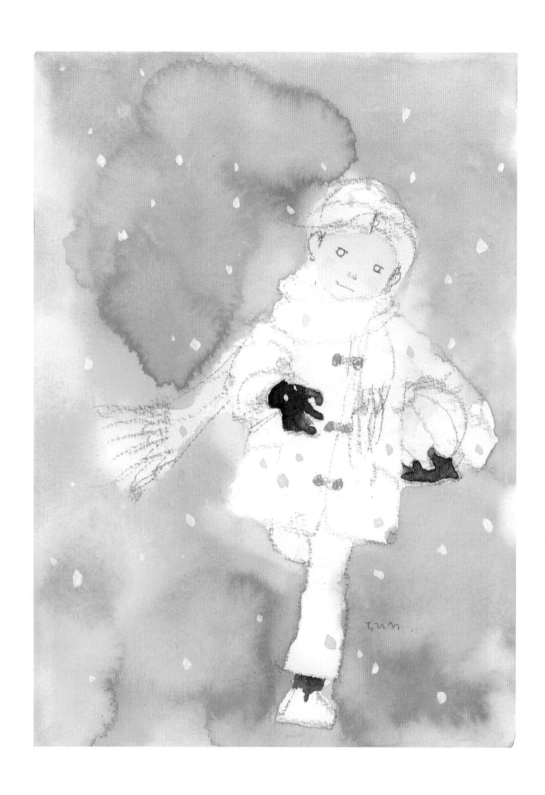

在雪中奔跑的孩子
Child Running in Snow

鉛筆、水彩、紙
Pencil, Watercolor on Paper
241 × 201mm ｜ 1970

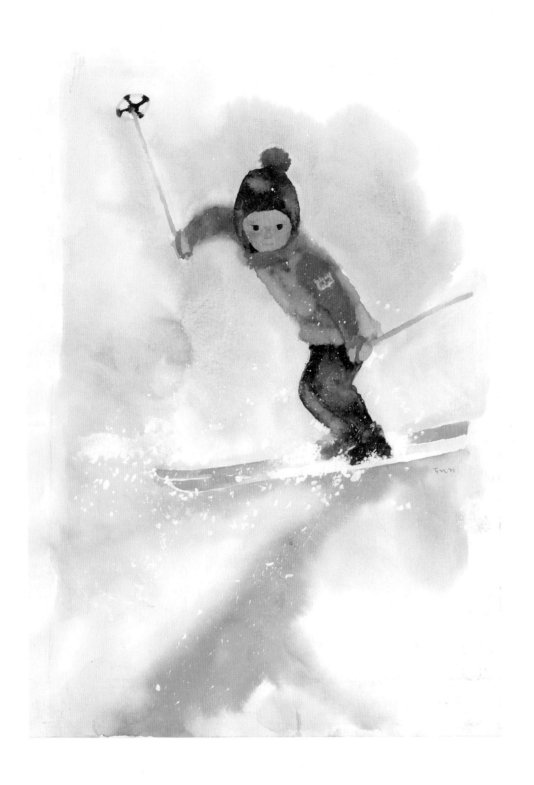

滑雪的男孩
Boy Skiing

水彩、紙
Watercolor on Paper
483 × 359mm ｜ 1969

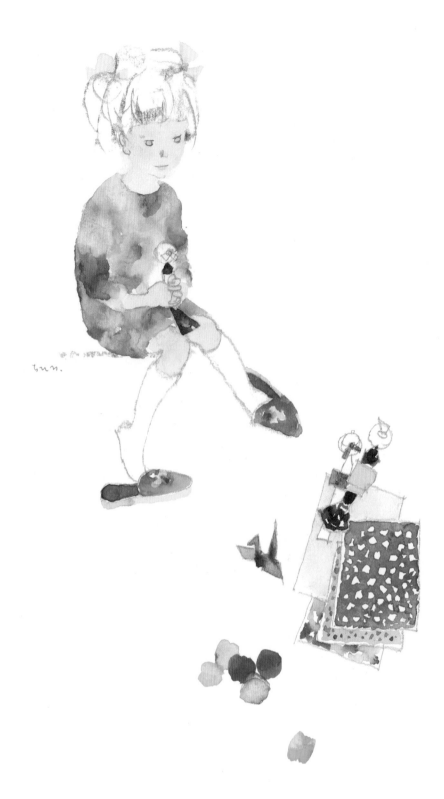

女孩與紙娃娃
Girl with Paper Dolls

鉛筆、水彩、紙
Pencil, Watercolor on Paper
484 × 359mm │ 1969

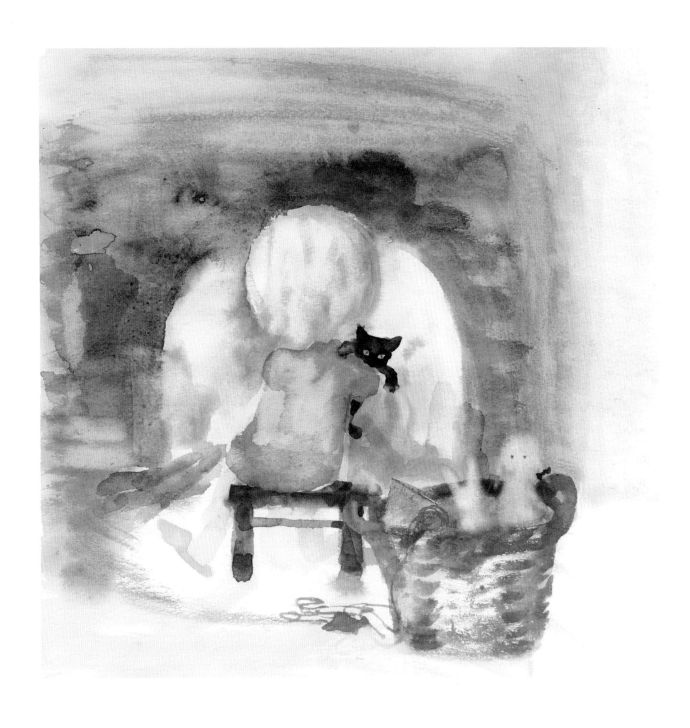

在爐邊抱著貓的女孩
Girl Hugging Her Cat by the Fireside

水彩、紙
Watercolor on Paper
357 × 345mm ｜ 1971

III

想樂

Playing Together

想樂

1951 年知弘產下唯一的兒子。除了就近有個小模特兒，加上她為人母的自覺，開始以孩童為作畫對象。知弘說：「我並沒有特別意識到，但如果是委託方沒有特別指定，我經常會在插畫中畫入自己的兒子」。

知弘自 1950 年代至 1960 年代期間，為一本名為「繪雜誌」的月刊投入創作。這本雜誌是針對幼稚園的孩子所編寫的童謠、童話或季節性的相關景物。知弘以兒子及其玩伴為模特兒，為這本雜誌創作。創作時，她特別注意幾個孩子的姿態以及相對位置，充分掌握孩子們生動活潑的動作，同時也考量到孩子們服裝的色調與花色的協調，描繪地十分仔細。從中可以感受到知弘對每個孩子的聯結、以及她那關注孩子身影的慈愛眼神。

Playing Together

In 1951, Chihiro gave birth to her only son. With a little model and self-awareness as mother, she started to portray children. "I didn't fully realize it until later. If customers didn't make specific requirements, though, I often included my son in illustrations," said Chihiro.

Chihiro produced many works for children's picture magazines in 1950s and 1960s. These publications introduced nursery rhymes, fairy tales and seasonal scenarios to kindergarten children. Chihiro created for these magazine based on her son and his playmates. She paid special attention to certain poses and relative positions between children to capture lively actions and movements. She also took colors and patterns of their clothes into considerations in her detailed paintings. Viewers can feel how much Chihiro is connected with children, and how she cares about children with love.

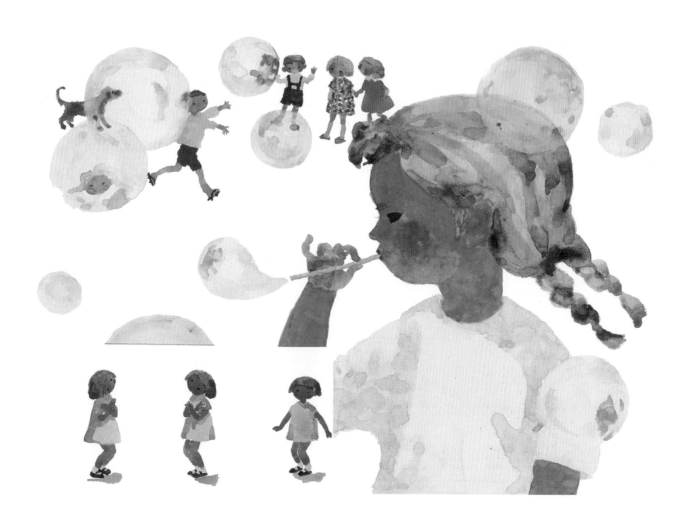

肥皂泡泡
Soap Bubbles

水彩、紙
Watercolor on Paper
263 × 173mm (Left), 268 × 184mm (Right) | 1954

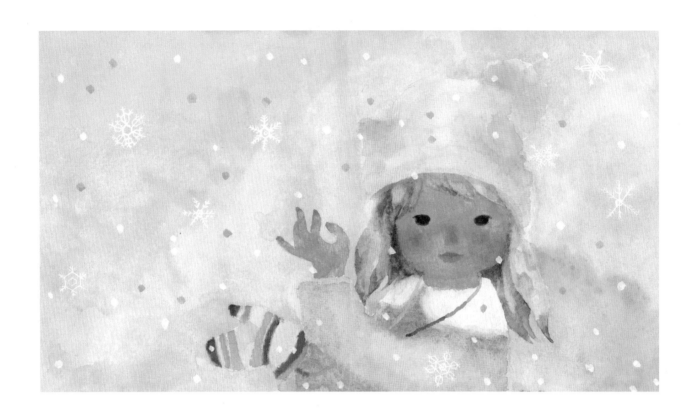

「飄起小雪」
"Light Snow Falling"

水彩、紙
Watercolor on Paper
208 × 370mm ｜ 1958

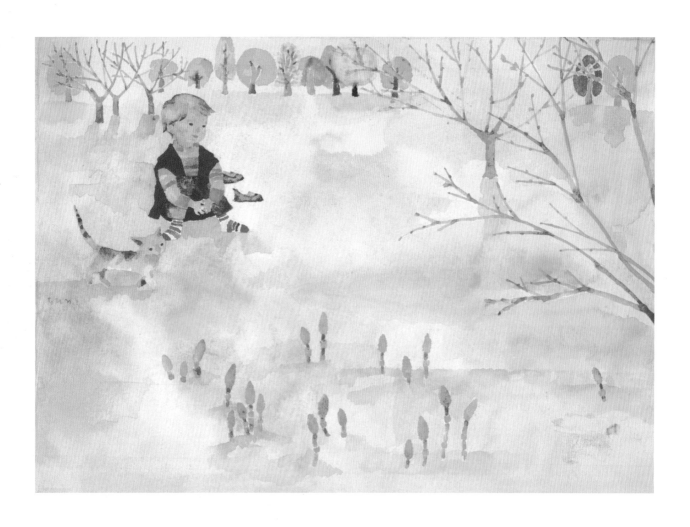

「春天」
"Spring"

水彩、紙
Watercolor on Paper
353 × 483mm │ 1958

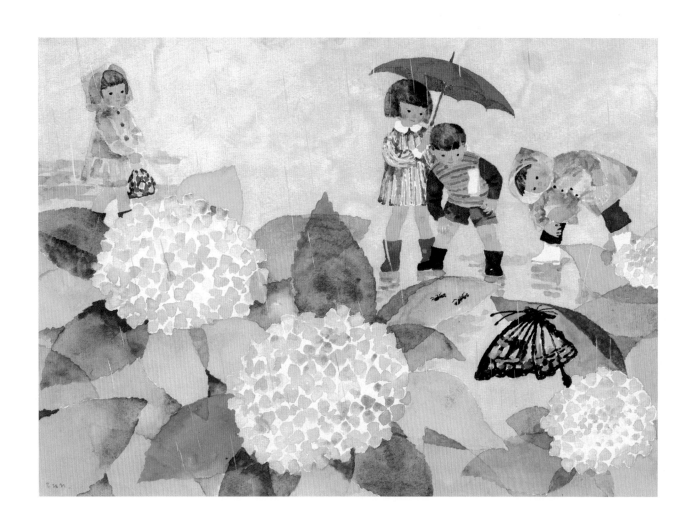

躲雨
Getting Out of the Rain

水彩、紙
Watercolor on Paper
314 × 431mm ｜ 1958

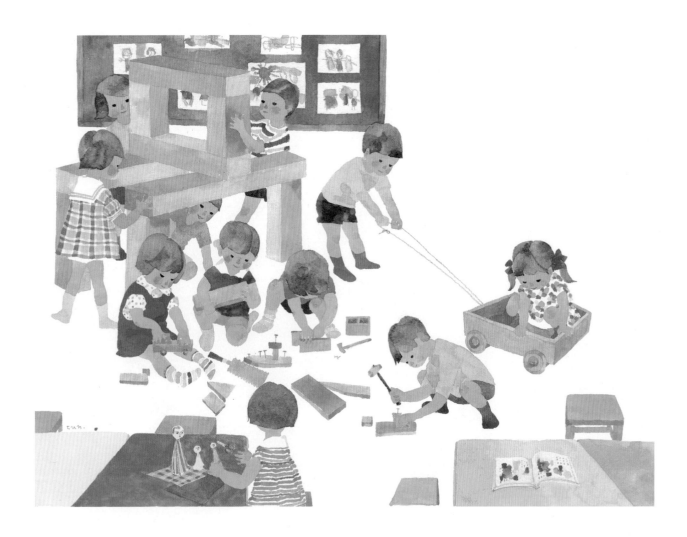

積木遊戲
Children Building with Wood

鉛筆、水彩、紙
Pencil, Watercolor on Paper
337 × 446mm ｜ 1961

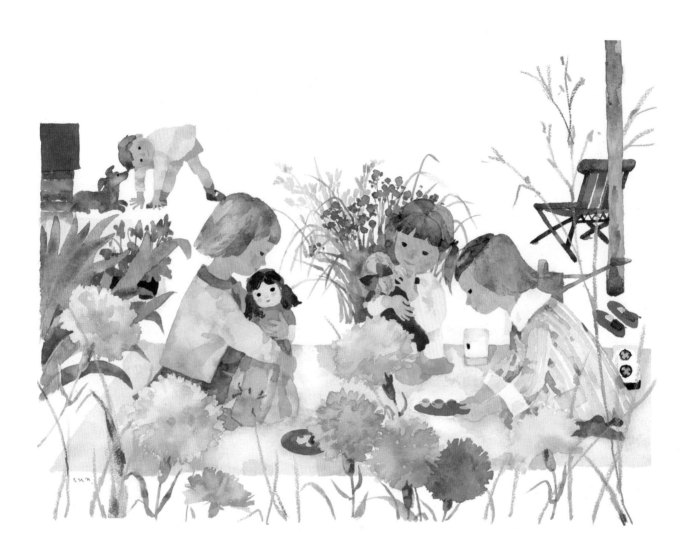

「扮家家酒」
"Playing House"

鉛筆、水彩、色鉛筆、紙
Pencil, Watercolor, Crayon on Paper
382 × 545mm ｜ 1963

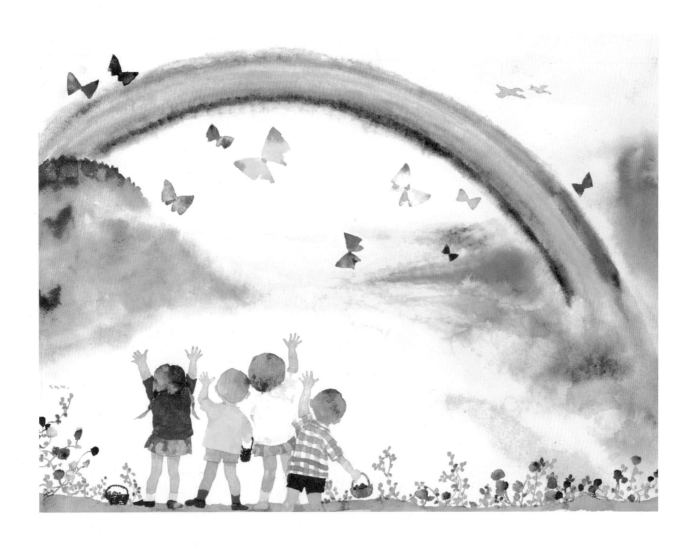

彩虹橋
Rainbow Bridge

水彩、紙
Watercolor on Paper
385 × 543mm ｜ 1963

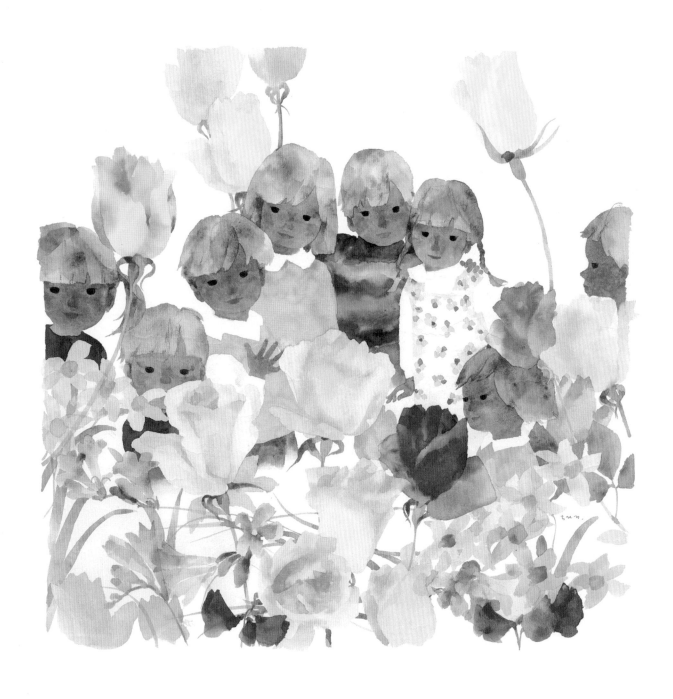

孩童們與春天的花朵
Children and Spring Flowers

鉛筆、水彩、紙
Pencil, Watercolor on Paper
670 × 717mm │ ca. 1965

IV

窗邊的小荳荳

Totto-Chan : The Little Girl at the Window

窗邊的小荳荳

《窗邊的小荳荳》是描寫一個小女孩因為常有特殊舉動，小一時遭退學而轉學到一所特殊教育機構—「巴氏學園」的學習歷程，這也是作者黑柳徹子本身的自傳文集。作者寫這本書時，岩崎知弘已經過世，但黑柳說：「當得知其遺作中有許多描寫孩子各種姿態的畫作，就決心開始執筆」。這些文章剛開始是在雜誌《年輕女性》上連載，而黑柳在百忙中仍抽空，持續二十三次親自到知弘美術館，和知弘的兒子松本猛一同挑選畫作以搭配連載。由於連載獲得極大好評，因此於 1981 年出版單行本，不僅立刻在日本國內躍登暢銷書，如今在全球已經有三十五種語言的譯本發行。

2014 年，為了讓幼齡讀者容易閱讀，出版了《窗邊的小荳荳》繪本，並新增許多知弘的彩色版畫作。此外，原本單行本中沒有的「大家一起來」，繪本出版時也在作者期待下，加入這部分內容。本展特別挑選十四幅原畫，搭配小荳荳的故事說明。

Totto-Chan: the Little Girl at the Window

Totto-Chan: The Little Girl at the Window is about an eccentric girl who transferred to a unique school Tomoe Gakuen after her expulsion from public school. It is an autobiographical story of the author Tetsuko Kuroyanagi. She started writing this book after the death of Chihiro Iwasaki knowing that Chihiro had many drawings of children. The Totto-Chan was originally published in Japan as a series of articles in Kodansha's *Young Woman* magazine, and the author visited the Chihiro Art Museum 23 times in order to pick up drawings fit her texts with Chihiro's son Takeshi Matsumoto. This series was highly acclaimed and in 1981 the collection of the series stories was published and soon became the best seller in Japan. Today, Totto-Chan has been translated into 35 languages.

The latest version of Totto-Chan was published in 2014. More illustrations have been included for little readers. A new chapter "We are all the same!" was added. In this exhibition, 14 original illustrations from this book are shown, together with the stories of the Totto-Chan.

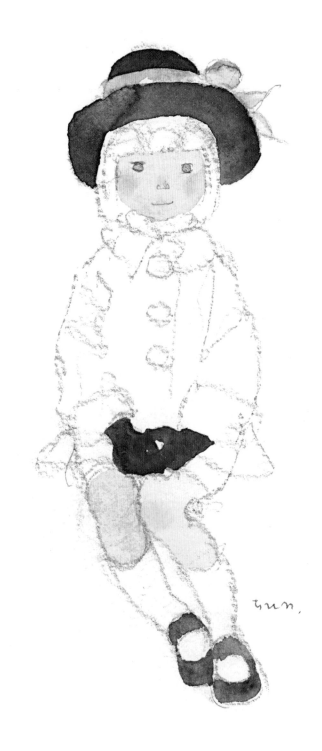

戴棕帽的女孩
Girl Wearing a Brown Hat

鉛筆、水彩、紙
Pencil, Watercolor on Paper
210 × 90 mm ｜ Early 1970s

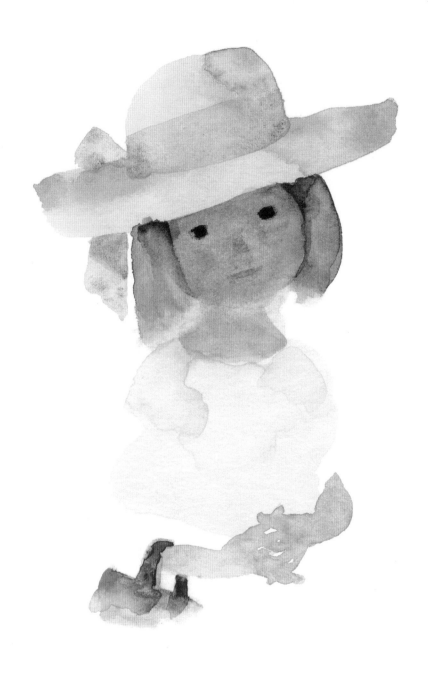

戴淡紫色帽子的女孩
Girl with Mauve Hat

水彩、紙
Watercolor on Paper
193 × 149 mm ｜ Early 1970s

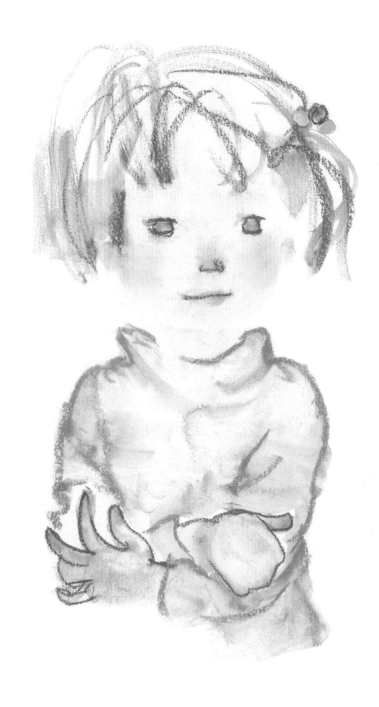

穿粉紅毛衣的女孩
Girl in Pink Sweater

水彩、粉彩、紙
Watercolor, Pastel on paper
482 × 358 mm ｜ 1970

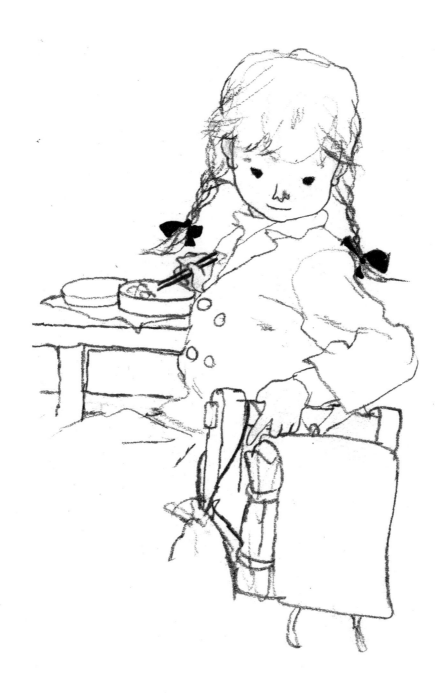

綁辮子的女孩吃午餐
Girl in Braids Eating Lunch

鉛筆、紙
Pencil on Paper
253 × 175 mm ｜ 1958

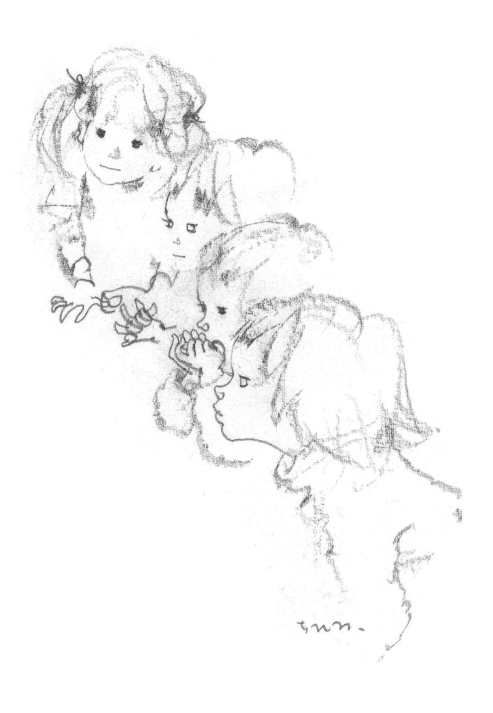

孩童看得目不轉睛
Children Gazing

鉛筆、紙
Pencil on Paper
242 × 180 mm ｜ 1969

在教室裡的孩子們
Children in Their Classroom

鉛筆、墨水、紙
Pencil, Chinese Ink on Paper
122 × 156 mm ｜ 1966

背著書包排隊的一年級學生
First Graders with Satchels Walking in Single File

水彩、紙
Watercolor on Paper
167 × 291 mm │ 1966

小女孩與男孩捧鍋子
Girl with Boy Holding a Pot

鉛筆、水彩、紙
Pencil, Watercolor on Paper
357 × 247 mm ｜ 1971

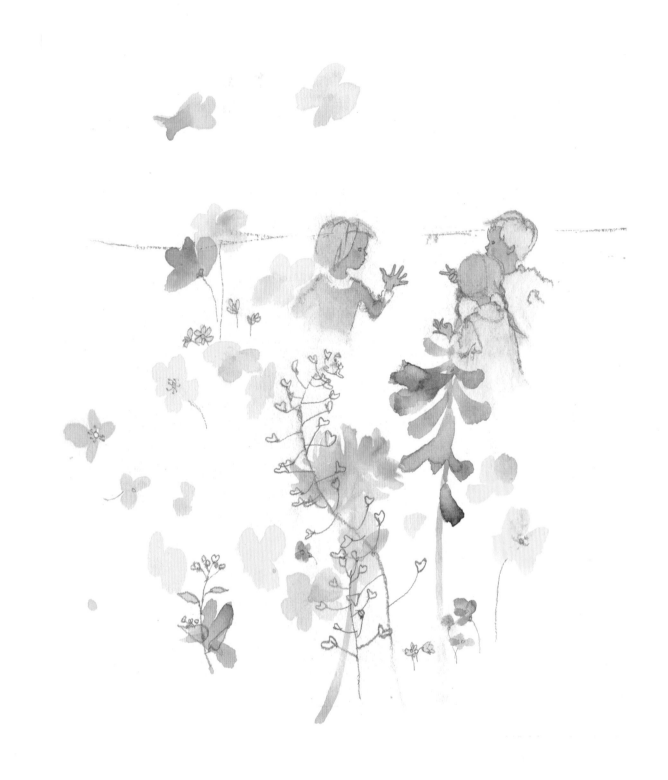

孩子們在春日田野間玩「剪刀、石頭、布」
Children Playing "Rock, Paper, Scissors" in a Field of Spring

鉛筆、水彩、紙
Pencil, Watercolor on Paper
241 × 357 mm ｜ 1970

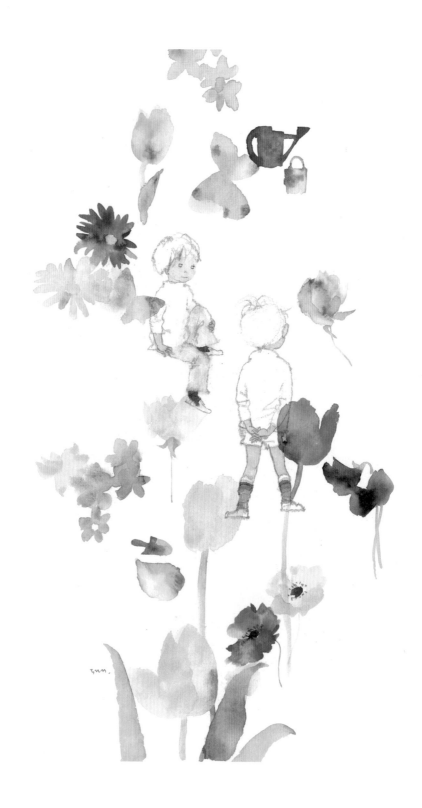

春日庭園
Spring Garden

鉛筆、水彩、紙
Pencil, Watercolor on Paper
484 × 333 mm ｜ 1969

女孩與蒲公英
Girl with Dandelions

水彩、紙
Watercolor on Paper
483 × 358 mm │ 1973

穿粉紅洋裝的女孩
Girl in Pink Dress

粉彩、紙
Pastel on Paper
357 × 242 mm ｜ 1970

女孩凝視著花朵
Girl Gazing at a Flower

鉛筆、紙
Pencil on Paper
267 × 185 mm ｜ 1968

大鳥與小鳥
Large Bird and Small Bird

水彩、紙
Watercolor on Paper
381 × 539 mm │ 1969

V

圖畫書選粹

Picture Books

圖畫書選粹

日本隨著繪本出版社日益增加，1960年代後期掀起一股繪本出版熱潮，知弘的繪本工作也急劇增加。身為家庭主婦，家務已經讓知弘極度繁忙，但她仍積極地投入繪本創作，並堅持追求自我的創作風格。知弘在談到自己的創作理念時說：「不受時下流行的畫風所影響，我由衷希望創作的是，永遠值得一讀再讀的繪本。有道是，最有個性的，也是最真實的，我要創作完全符合自己理念的繪本。同時，我希望童畫世界裡，永遠不再有插畫的用詞。童畫不是文章的附帶說明而已，就如同文章的表現般，這些畫是以不同面向傳達，係是一種獨立而重要的藝術。」

二戰後的日本，繪本仍處於以故事性繪本為主的草創期，而始終追求繪本創新表現的知弘成了極大的推手，為後續日本繪本表現帶來極大的可能性，可說是樹立了一種典範。知弘一生創作四十多本繪本，其中多數至今仍持續再版，父母到孩子、孩子到孫子、成了世代傳承的最佳讀物。

Picture Books

In the late 1960s, number of publishing houses for picture books increased significantly in Japan, and Chihiro was offered a lot of jobs. As a housewife, Chihiro was already engaged by many household chores, but she still actively created without compromising her own style. When talking about her creation, Chihiro said, "I don't want to be influenced by the trendy styles of painting, what I deeply want is to produce picture books that are most characterized and truthful, and will be read again and again. I want to make picture books that completely fit my idealism. And I hope illustrations of children's books are no longer secondary to the texts. Like an essay, these paintings are also independent elements, they are art carrying out ideas."

After the World War II, the production of picture books in Japan picked up, Chihiro became one of the major pushers of their creative development, and successfully brought up the great diversity of picture books published in Japan. Chihiro became a role model, and the more than 40 picture books she had created have been printed and reprinted, and passed on from generation to generation. They are the greatest legacy left by Chihiro.

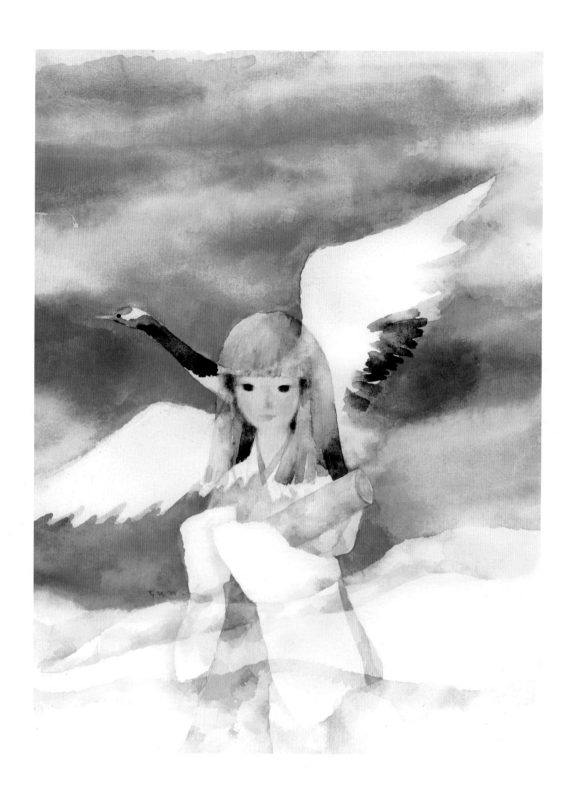

夕陽下的女孩與白鶴
The Girl and the Crane in the Sunset

鉛筆、水彩、紙
Pencil, Watercolor on Paper
333 × 241 mm │ 1966

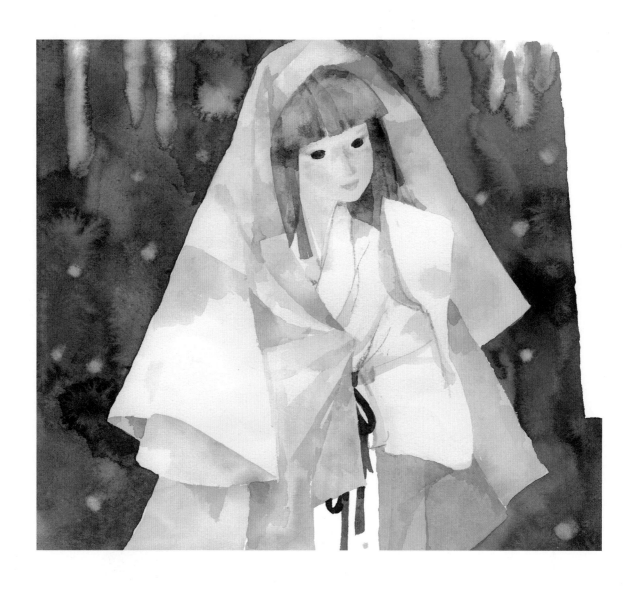

鶴姑娘於下雪天翩然而至
The Maiden Arrives on a Snowy Day

鉛筆、水彩、紙
Pencil, Watercolor on Paper
356 × 483 mm ｜ 1966

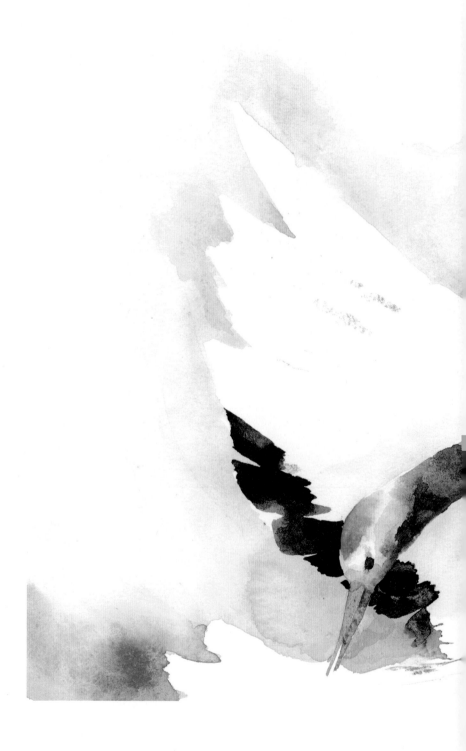

老翁解救白鶴
The Old Man Saving the Crane's Life

鉛筆、水彩、紙
Pencil, Watercolor on Paper
356 × 483 mm ｜ 1966

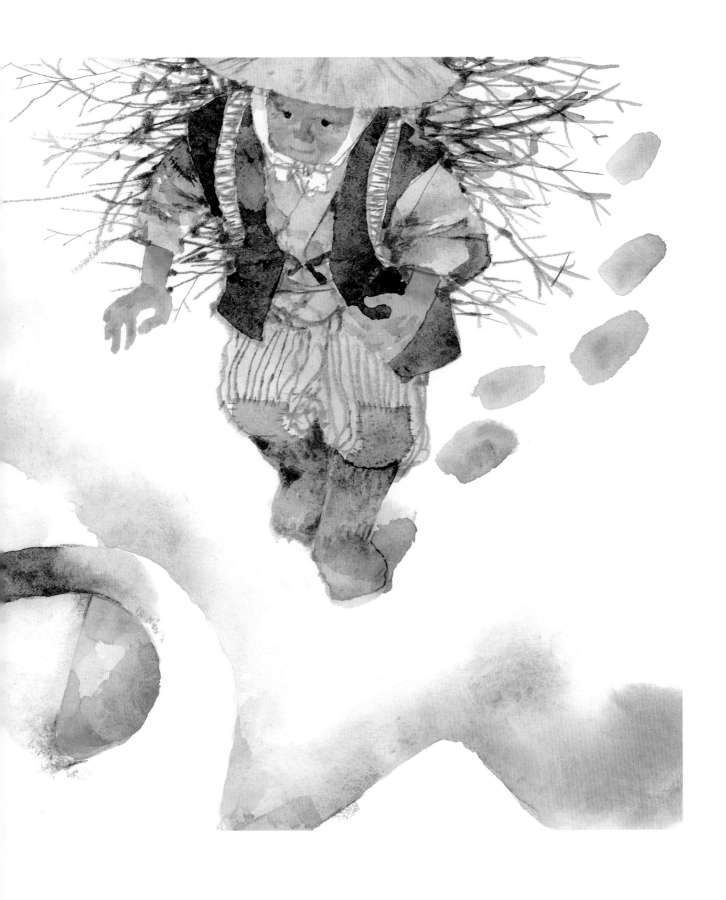

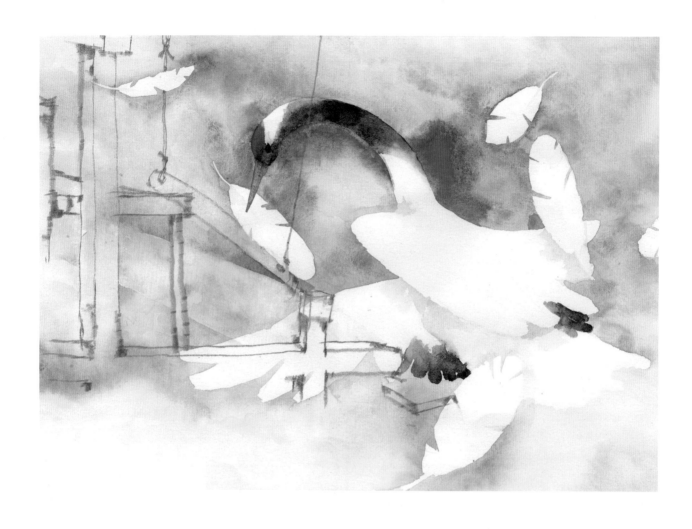

白鶴展翅
The Crane Weaving

鉛筆、水彩、紙
Pencil, Watercolor on Paper
360 × 482 mm ｜ 1966

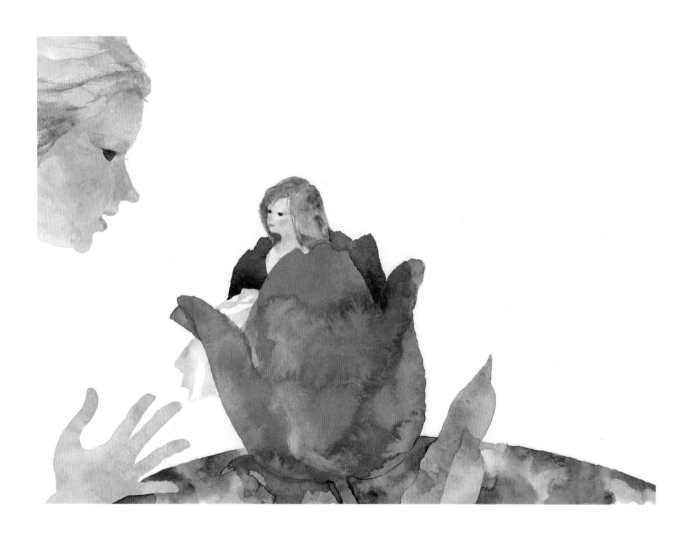

拇指姑娘從花中誕生
Thumbelina, Born out of a Flower

鉛筆、水彩、紙
Pencil, Watercolor on Paper
356 × 484 mm │ 1966

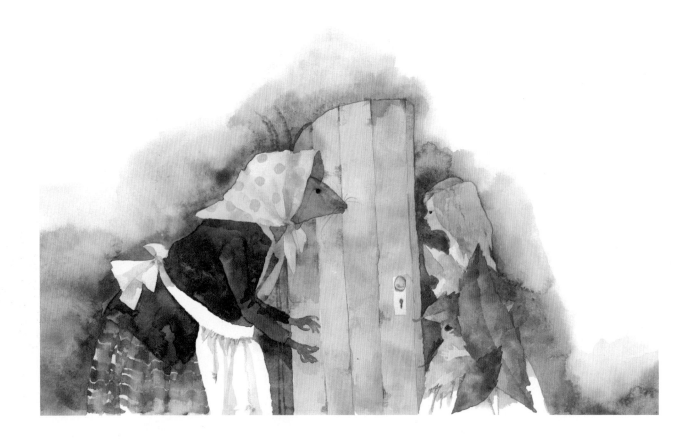

拇指姑娘與田鼠婆婆
Thumbelina and the Field Mouse Lady

鉛筆、水彩、紙
Pencil, Watercolor on Paper
356 × 484 mm │ 1966

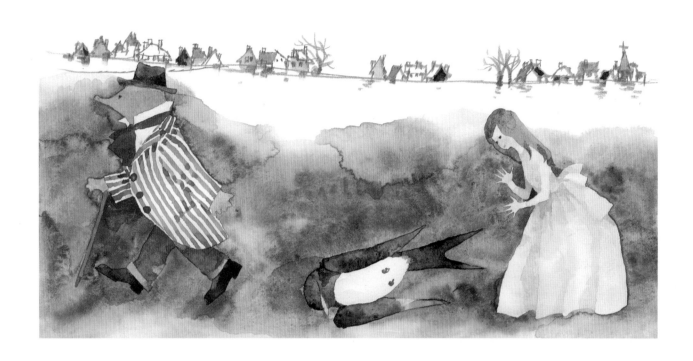

田鼠婆婆、鼴鼠與受傷的燕子
Thumbelina, the Mole, and the Wounded Swallow

鉛筆、水彩、紙
Pencil, Watercolor on Paper
357 × 484 mm ︱ 1966

拇指姑娘與王子
Thumbelina and the Flower Prince

鉛筆、水彩、紙
Pencil, Watercolor on Paper
358 × 484 mm ｜ 1966

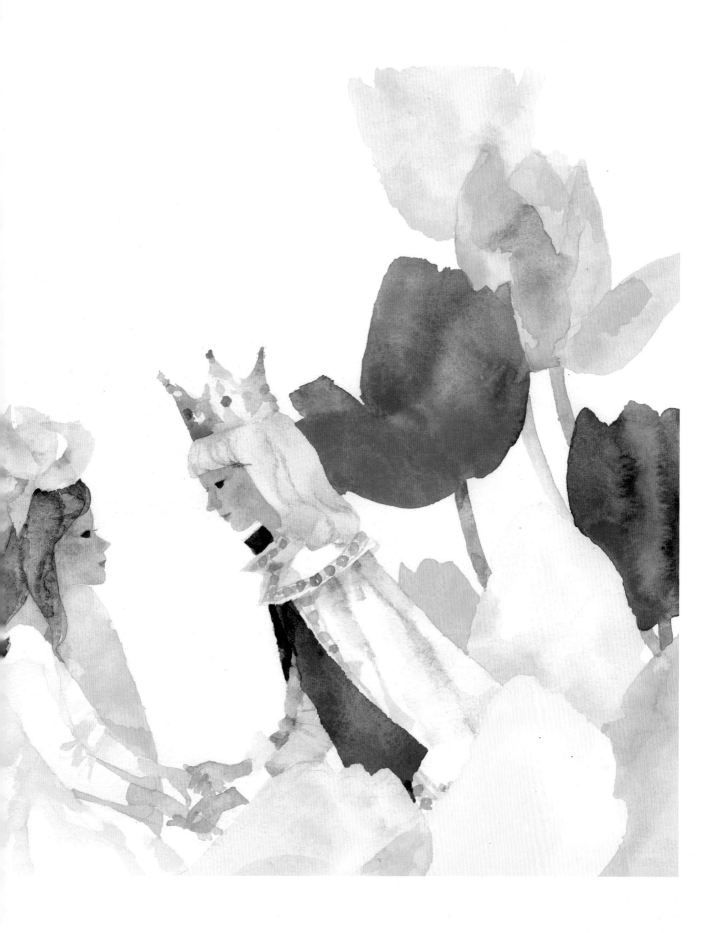

男人想像月亮看見什麼
The Man Imagining What the Moon Saw

鉛筆、墨水、紙
Pencil, Chinese Ink on Paper
204 × 125 mm ｜ 1966

演技不佳的演員
Incompetent Actor

鉛筆、墨水、紙
Pencil, Chinese Ink on Paper
210 × 179 mm ｜ 1966

坐在欄杆上的中國女孩
Chinese Girl Sitting on the Railing

鉛筆、墨水、紙
Pencil, Chinese Ink on Paper
212 × 179 mm ｜ 1966

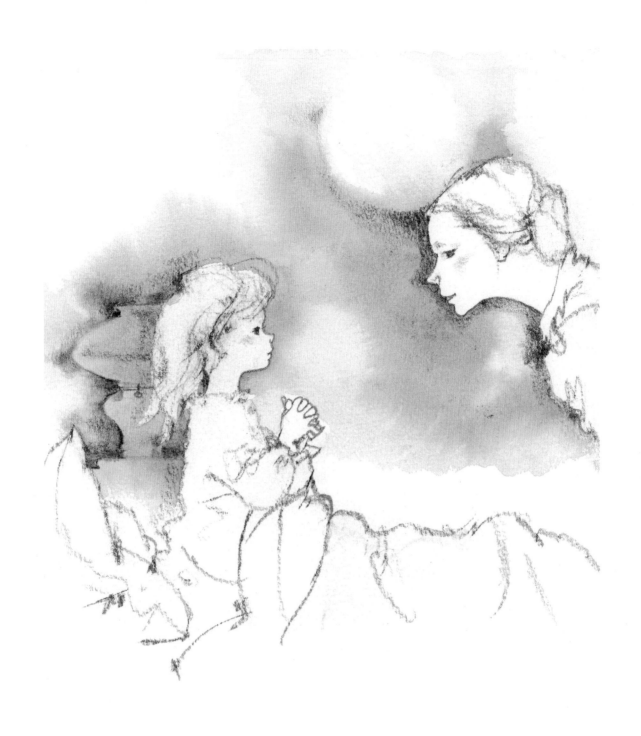

小女孩在床上與母親一起禱告
Little Girl Praying in Bed with Her Mother

鉛筆、墨水、紙
Pencil, Chinese Ink on Paper
210 × 186 mm | 1966

戴草帽的鬼太
Onita Wearing a Straw Hat

鉛筆、水彩、紙
Pencil, Watercolor on Paper
360 × 484 mm ｜ 1969

走在雪中的鬼太
Onita Walking in the Snow

鉛筆、水彩、紙
Pencil, Watercolor on Paper
359 × 483 mm ｜ 1969

鬼太到廚房去察看
Onita Looking into the Kitchen

鉛筆、水彩、紙
Pencil, Watercolor on Paper
358 × 484 mm ｜ 1969

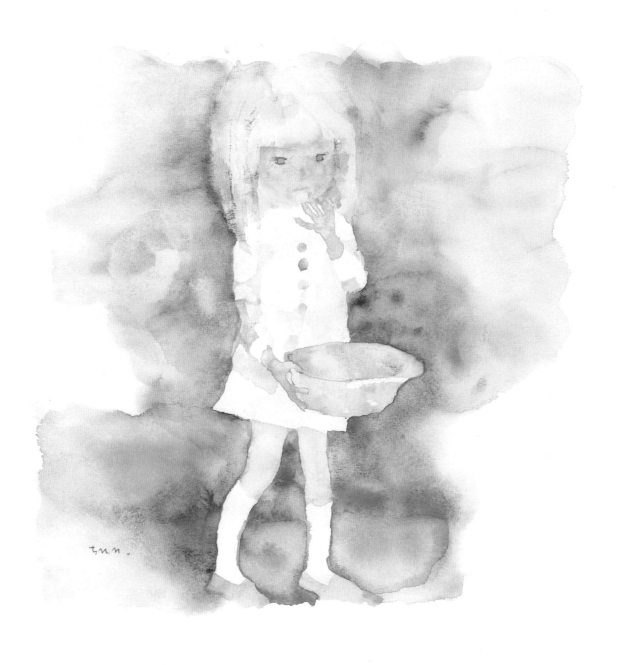

拿著水盆的女孩
The Girl Holding a Washbowl

鉛筆、水彩、紙
Pencil, Watercolor on Paper
359 × 482 mm ｜ 1969

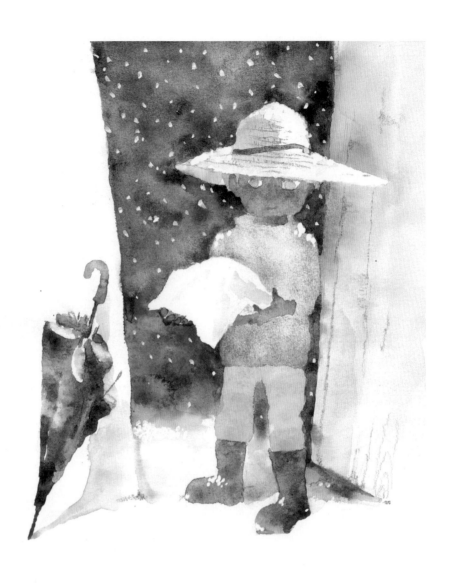

站在門邊的鬼太
Onita Standing at the Door

鉛筆、水彩、紙
Pencil, Watercolor on Paper
359 × 483 mm ｜ 1969

鬼太給女孩紅豆飯
Onita Giving the Girl Cooked Rice with Red Beans

鉛筆、水彩、紙
Pencil, Watercolor on Paper
361 × 484 mm ｜ 1969

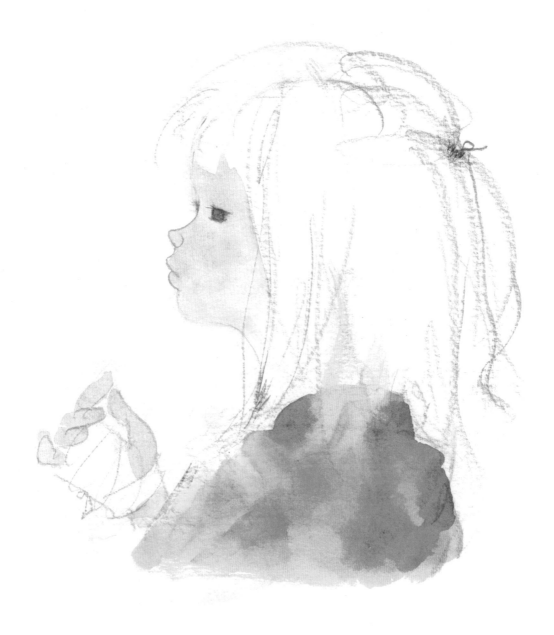

手上綁著繃帶的久兒
Hisa with Her Hand Bandaged

鉛筆、水彩、紙
Pencil, Watercolor on Paper
360 × 355 mm ｜ 1972

溪水暴漲
Rising River

水彩、紙
Watercolor on Paper
358 × 482 mm ｜ 1972

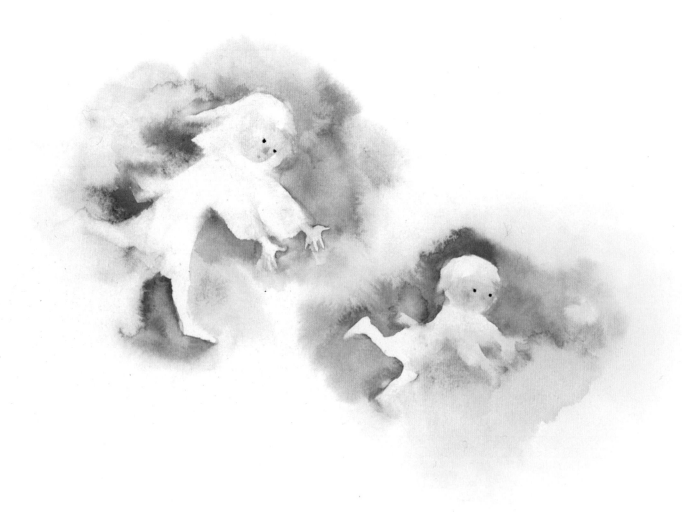

久兒追趕小吉
Hisa Running after Masakichi

水彩、紙
Watercolor on Paper
359 × 483 mm │ 1972

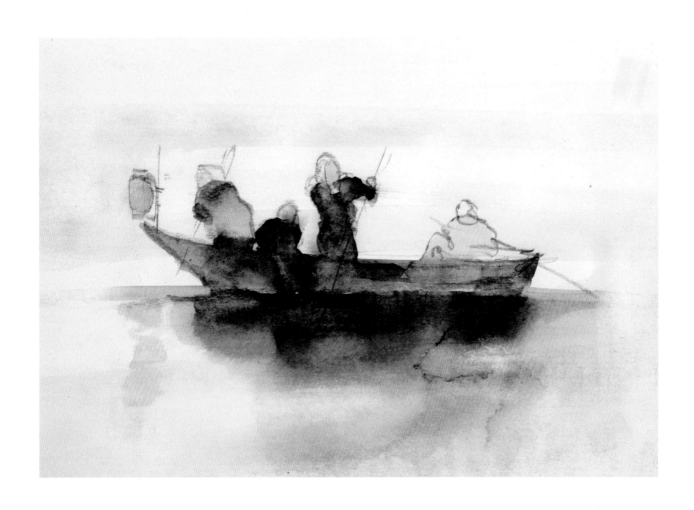

村民划船找尋久兒
The Village People on a Boat Searching for Hisa

鉛筆、水彩、紙
Pencil, Watercolor on Paper
190 × 265 mm ｜ 1972

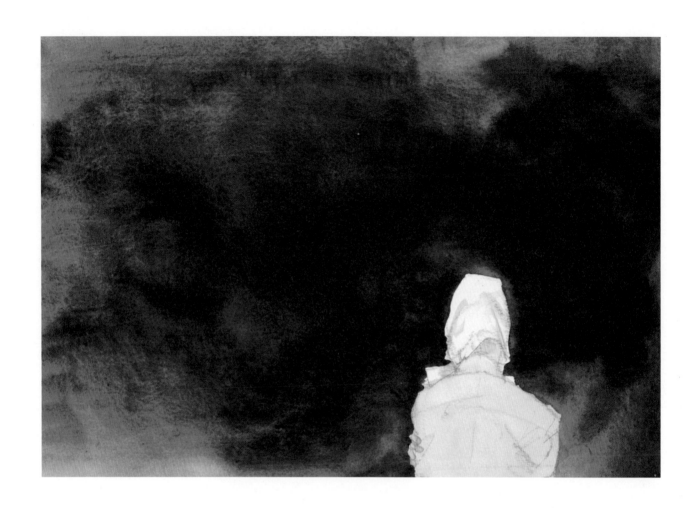

男人凝視暗處
A Man Staring into the Darkness

鉛筆、水彩、紙
Pencil, Watercolor on Paper
339 × 482 mm ｜ 1972

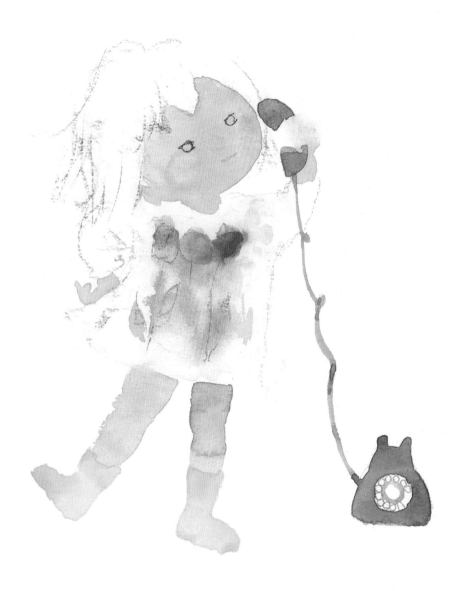

小女孩打電話
The Girl Calling

鉛筆、水彩、紙
Pencil, Watercolor on Paper
262 × 484 mm ｜ 1970

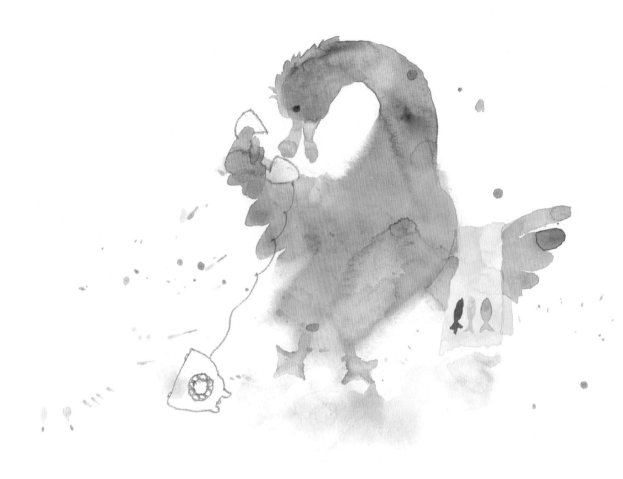

鴨子講電話
The Duck Talking on the Telephone

鉛筆、水彩、紙
Pencil, Watercolor on Paper
262 × 371 mm │ 1970

蒲公英電話亭
The Dandelion's Telephone Office

鉛筆、水彩、紙
Pencil, Watercolor on Paper
269 × 396 mm │ 1970

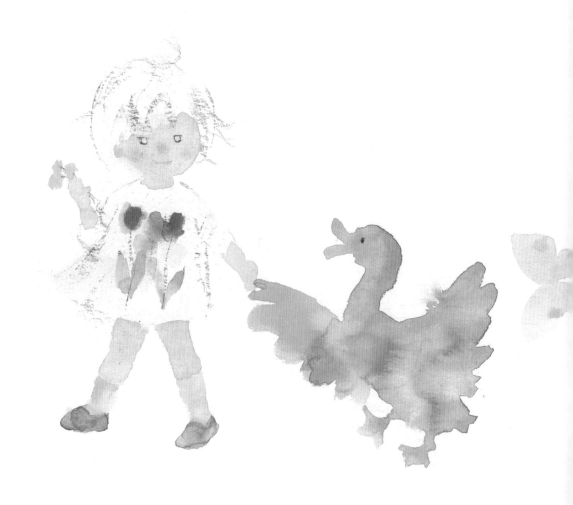

散步
Taking a Walk

鉛筆、水彩、紙
Pencil, Watercolor on Paper
265 × 485 mm ｜ 1970

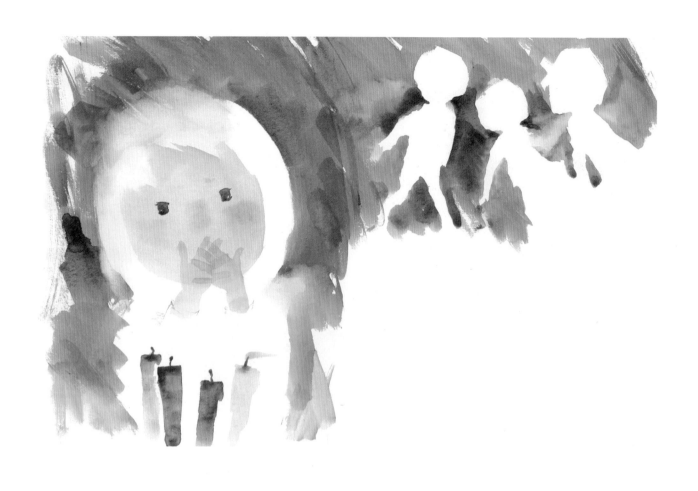

小女孩吹蠟燭
The Girl Who Blew out the Candles by Mistake

鉛筆、水彩、紙
Pencil, Watercolor on Paper
385 × 648 mm ｜ 1972

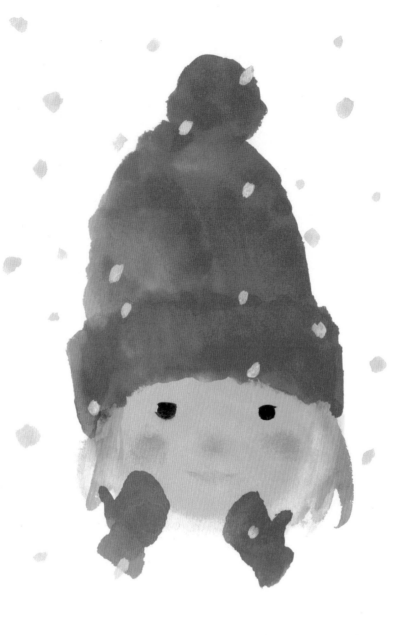

戴紅色羊毛帽的女孩
The Girl Wearing a Red Woolen Cap

水彩、紙
Watercolor on Paper
327 × 361 mm ｜ 1972

夕陽下的女孩
The Girl at Sunset

鉛筆、水彩、紙
Pencil, Watercolor on Paper
362 × 544 mm ｜ 1972

被白雪覆蓋的屋舍
The Snow-covered Houses

水彩、紙
Watercolor on Paper
384 × 544 mm ｜ 1972

生日派對
The Birthday Party

鉛筆、水彩、紙
Pencil, Watercolor on Paper
386 × 545 mm ｜ 1972

VI

為和平祈願

Chihiro's Wish for Peace

為和平祈願

1910 到 1920 年代,日本對兒童文化投注大量心力,這個時候的岩崎知弘正值幼年時期;她的青春期,為 1930 年代日本舉國投入侵略戰爭的相同時期。1944 年,第二次世界大戰期間,岩崎知弘到中國東北方(偽滿州)教書,對象是日本移民開拓訓練所裡的女孩們。她在那裡親眼看到在日本本土不曾聽聞的諸多慘狀,飽受衝擊。回到東京之後,住家因為美軍空襲而燒毀,一整夜在到處失火的街道中逃竄。親身經歷過腐蝕人心、奪走眾多寶貴生命的殘酷戰爭,對她往後的人生產生了決定性的影響。

二次世界大戰後,岩崎知弘成為畫家,終生以孩童為創作題材。在她的眼裡,每個孩子的美,都是無可取代的存在。她筆下的嬰兒眼睛圓潤好像會說話,頭髮柔軟,皮膚細嫩的質感呼之欲出,那是一種連結未來的生命光輝的氛圍。她晚年因病所苦,畫作中飽受戰禍蹂躪的孩子們,和先前備受關愛的嬰兒,完全是不同的形象。無論哪一種型態的畫作,都有她祈求「全世界的孩子都平和喜樂」的心意。岩崎知弘用她自己的表現方式,與威脅兒童者對決,一方面也質問何謂生命的尊嚴?真正的溫柔、真正的美又為何?

Chihiro's Wish for Peace

In the 1910s and the 1920s, when Chihiro Iwasaki was in her childhood, culture for children was flourishing in the Japanese society. When she turned into a teenager in the 1930s, the entire society of Japan was preparing for wars. In 1944, the year before the World War II was over, Chihiro Iwasaki went to northeastern China(Manchuria, a puppet state established by Japan) to teach calligraphy, her students were Japanese girls taking training as immigrants. There she witnessed the atrocities she never heard of back at home in Japan, and was very shocked. After returning to Japan, she had experienced running all night through the flames caused by air raids. The cruelty of wars and how it could destroy people's lives had forever changed Chihiro's course of life.

After the World War II, Chihiro Iwasaki became a professional artist and devoted herself in illustration for children. To her, every child was beautiful, every child was precious. Babies drawn by Chihiro have bright, expressive eyes, soft hair and delicate skin. They are the future, they bring us hope. During the last years of her life, Chihiro suffered from illness, and her portraits of children in wars had very different appearances compared to the beloved children of her earlier works. In both phases of her art career, her wishes of peace and happiness for children were the same. Chihiro confronted those threatened children with her art, and at the same time, asserted that tenderness and beautify of life couldn't exist without the dignity of life.

在兔耳花叢中的孩子
Children among Cyclamen Flowers

鉛筆、水彩、紙
Pencil, Watercolor on Paper
359 × 484 mm ｜ 1973

男孩
Boy

鉛筆、水彩、紙
Pencil, Watercolor on Paper
357 × 364 mm ｜ 1973

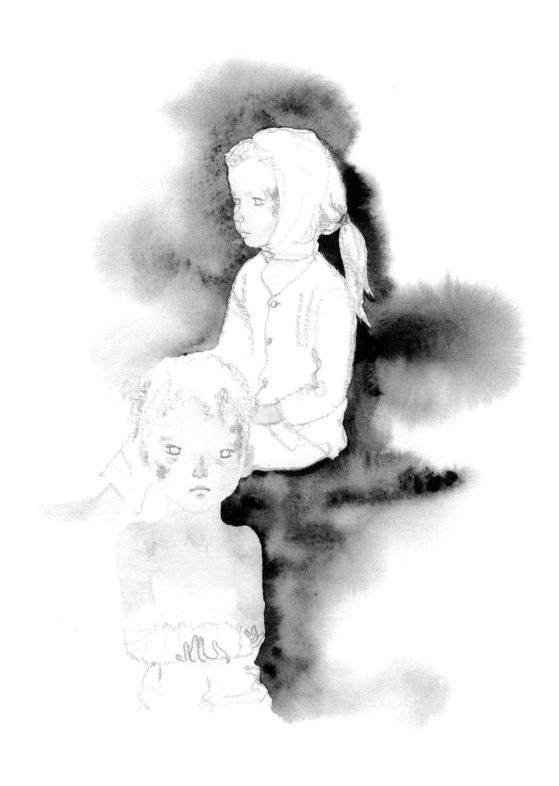

受傷的孩子
Wounded Children

鉛筆、墨水、紙
Pencil, Chinese Ink on Paper
385 × 545 mm ｜ 1973

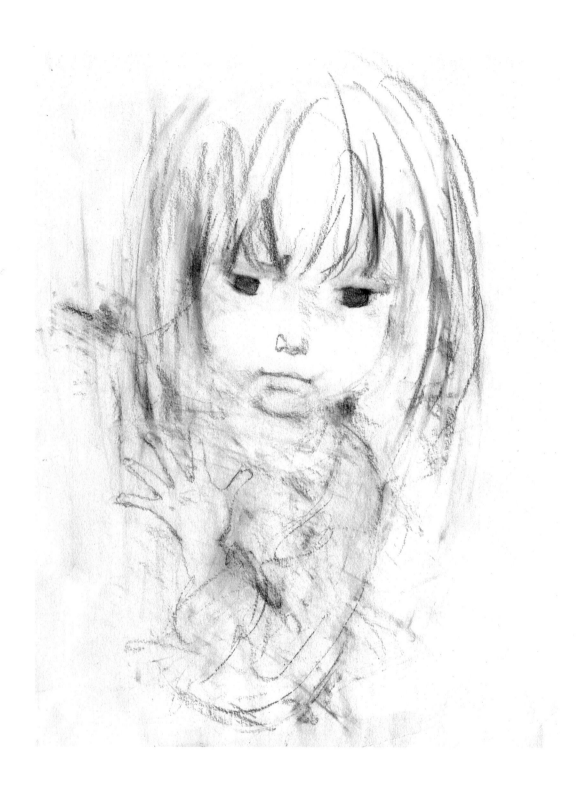

環視角落的女孩
Girl Looking around the Corner

鉛筆、紙
Pencil on Paper
452 × 360 mm ｜ 1973

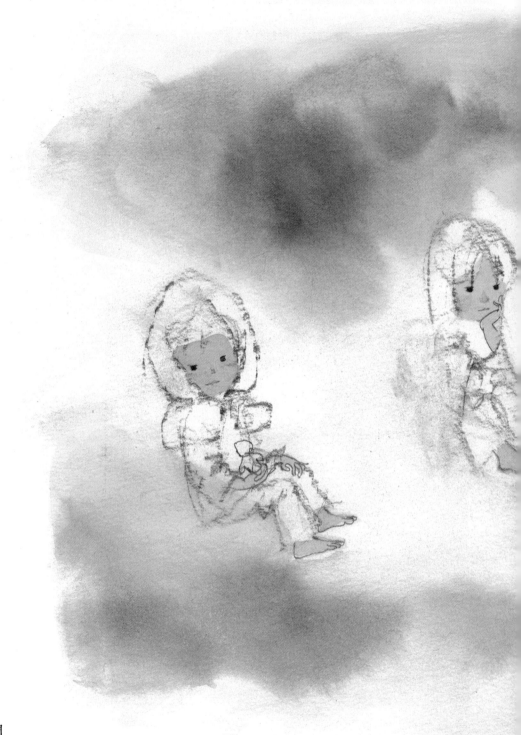

躲在空襲避難所的孩子們
Children in Air-Raid Shelter

鉛筆、墨水、紙
Pencil, Chinese Ink on Paper
360 × 550 mm │ 1973

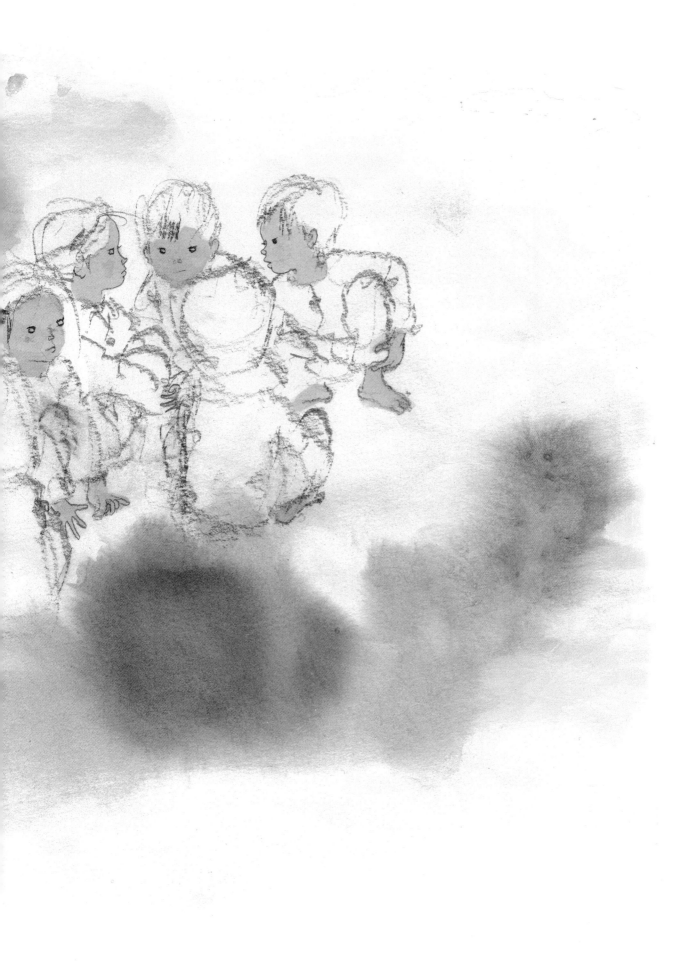

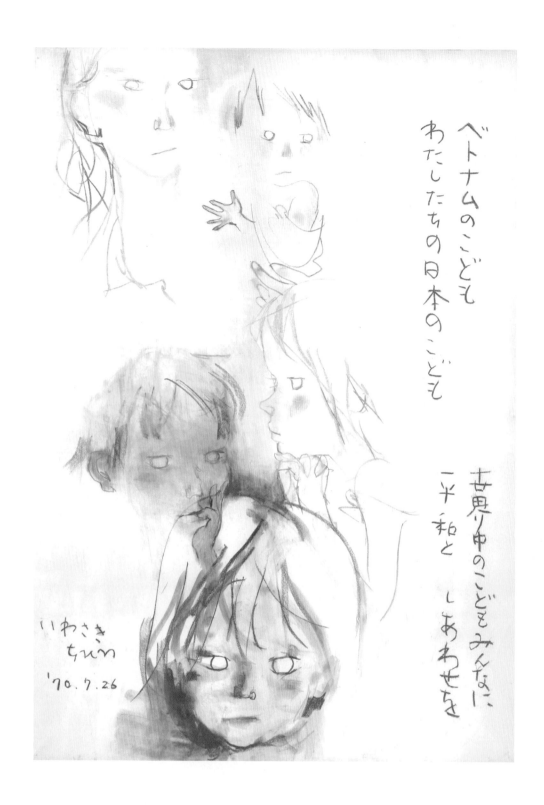

「願全世界的孩子都平和喜樂」
"Wishing Peace and Happiness for All the Children of the World"

粉彩、紙
Pastel on Paper
1035 × 730 mm ｜ 1970

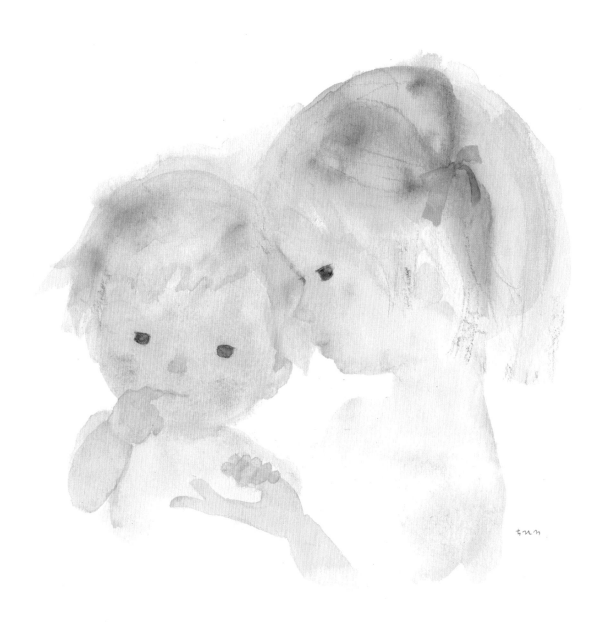

大姊姊與小弟弟
Big Sister and Her Baby Brother

鉛筆、水彩、紙
Pencil, Watercolor on Paper
243 × 318 mm ｜ 1971

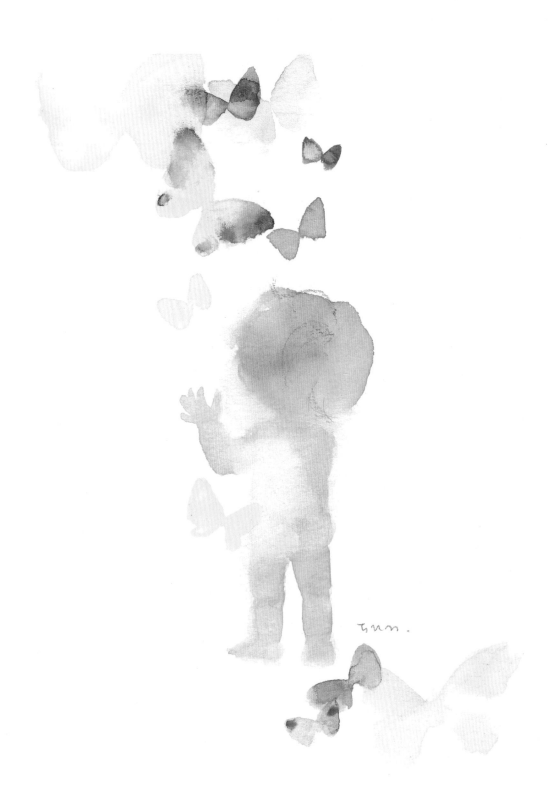

寶寶與蝴蝶
Baby and Butterflies

鉛筆、水彩、紙
Pencil, Watercolor on Paper
180 × 120 mm ｜ 1971

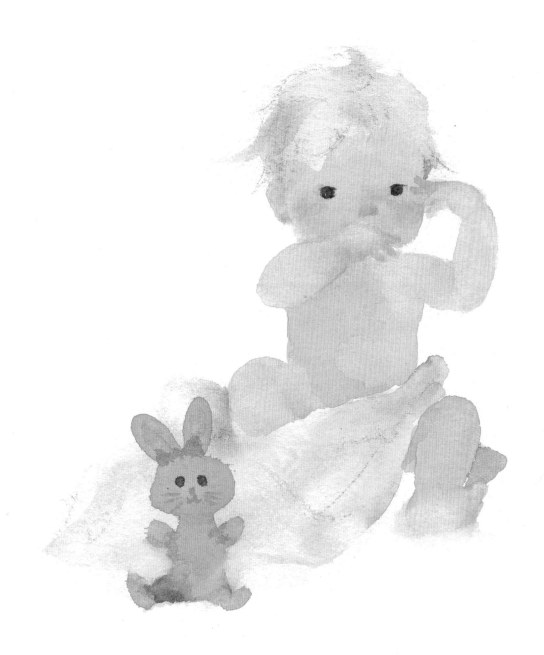

粉紅兔子與寶寶
Pink Rabbit and Baby

鉛筆、水彩、紙
Pencil, Watercolor on Paper
179 × 241 mm ｜ 1971

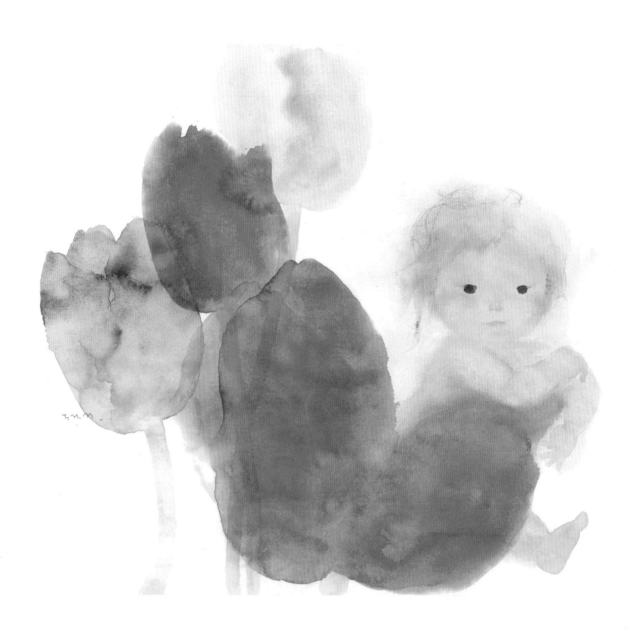

鬱金香花叢中的寶寶
Baby among Tulips

鉛筆、水彩、紙
Pencil, Watercolor on Paper
357 × 430mm ｜ 1971

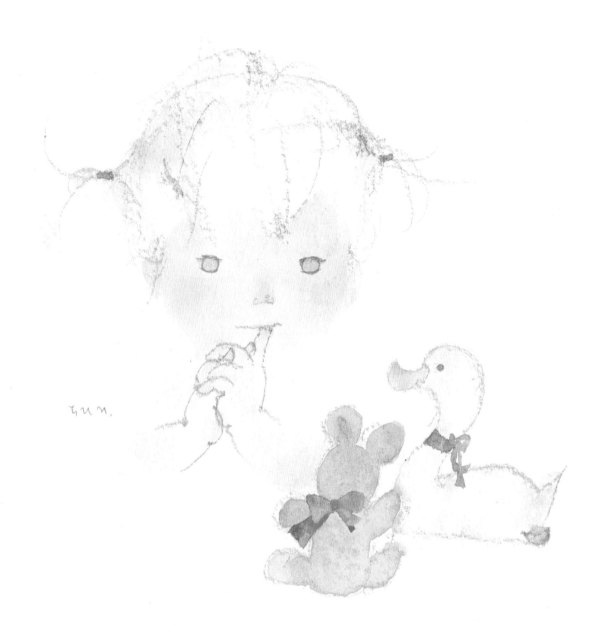

寶寶、鴨子和泰迪熊
Baby, Duck and Teddy Bear

鉛筆、水彩、紙
Pencil, Watercolor on Paper
241 × 234 mm ｜ 1971

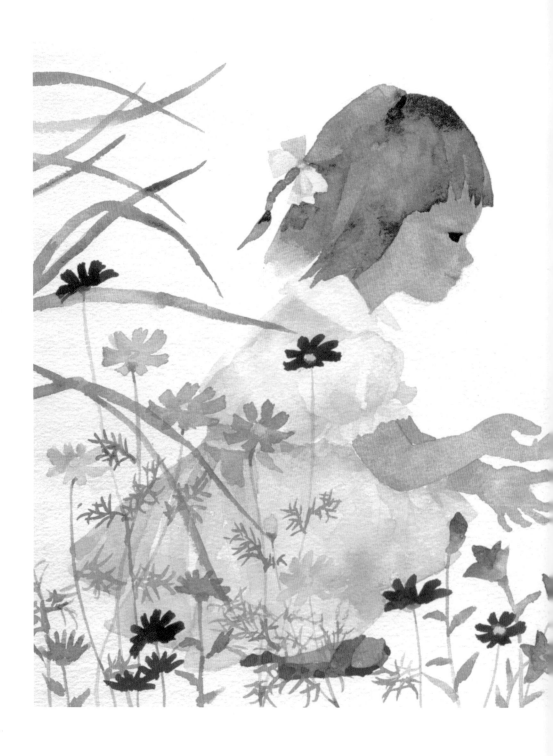

寶寶走向姊姊
Baby Walking towards His Big Sister

水彩、紙
Watercolor on Paper
366 × 484 mm │ Late 1960s

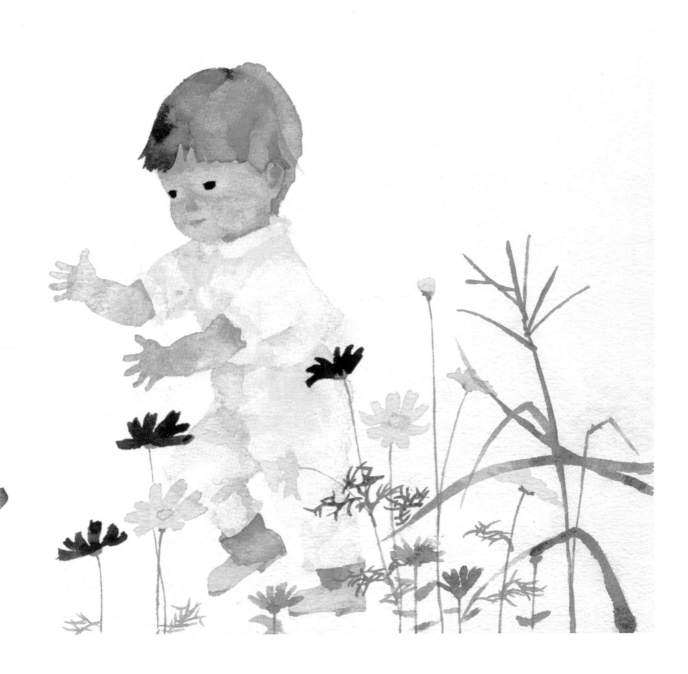

年表
Chronology

年表

出生 57 天的知弘，1919
Chihiro, 57 days after birth, 1919

全家福，1928
Family picture at the time of parents'
attendance, 1928

1918
12 月 15 日 長女知弘出生於福井縣。
Born on December 15 as the eldest daughter of Masakatsu and Fumie Iwasaki in Takefu Town (now Echizen City), Fukui Prefecture, where her mother worked away from home.

1919
搬到東京澀谷區的道玄坂。
Moves to an area in what is currently Dogenzaka, Shibuya-ku, Tokyo.

1920　　(1year old)
知弘妹妹世史子出生。
Chihiro's sister Yoshiko born.

1922　　(3 years old)
搬到澀谷區的惠比壽。
喜歡岡本歸一、初山滋、武井武雄的繪畫。
Moves to Shitan-cho, (now Shibuya-ku).
Enjoys illustrations for children created by Kiichi Okamoto, Shigeru Hatsuyama, Takeo Takei, and others.

1923　　(4 years old)
知弘妹妹準子出生。
Chihiro's sister Junko born.

1925　　(6 years old)
就讀小學。
Enters Shibuya Municipal Hasedo Elementary School.

1927　　(8 years old)
在學校經常為園遊會演出即興作畫。
Often draws *sekiga* (impromptu drawings) for gatherings such as school plays.

1931　　(12years old)
就讀東京府立第六女子高中。
每年夏天跟隨學校營隊去長野的中房溫泉；經常到北阿爾卑斯山遠足。
Enters Tokyo Prefectural Sixth Girls' High School (currently the Tokyo Metropolitan Mita High School).
Visits Nakabusa hot spring (Nagano) every summer under the camp school program; often goes hiking in the Northern Japanese Alps.

1932　　(13 years old)
由於父親的影響，在學校時密切關注東京六大棒球聯賽比賽。經常去金

在安曇野中房溫泉，1928
At Nakabusa Hot Springs, Nagano prefecture, 1928

府立第六女子高中五年級，1928
Fifth year at the Sixth Girls' High School, 1935

谷體育場。

擅長許多運動；經常打籃球，練習游泳和弓道（日本傳統弓術）；喜歡到山上滑雪和徒步旅行。

Closely follows the Tokyo Big 6 Baseball League tournament while in school, due to the influence of her father; frequently goes to Jingu Stadium Excels in many sports; often plays basketball and practices swimming and kyudo (Japanese archery); enjoys skiing and hiking in the mountains.

1933 (14 years old)
搬家到目黑區目黑，師從岡田三郎助，開始學習油畫和素描。

Moves to Naka-Meguro, Meguro-ku and begins study of sketching and oil painting under Saburosuke Okada.

1936 (17 years old)
府立第六女子高中畢業，隨後進入學校的補習課程。
入選女子西洋畫展。

In March, graduates from Tokyo Prefectural Sixth Girls' High School and subsequently enters supplementary courses of the school.
In May, her work is accepted for the Shuyokai Exhibition of Western-style Painting by Women Artists.

1937 (18 years old)
跟隨小田周洋學習藤原行成流的書法。

Begins to study Fujiwara-no-Kozei-style calligraphy under Shuyo Oda.

1939 (20 years old)
依父母之命結婚，前往丈夫工作的地方，中國大連。

Marries in April and in June moves to Dalian in Liaoning Province, China, where her husband works.

1940 (21 years old)
母親文江從府立第六女子高中退休，主管日本聯合女子青年團（之後的日本青年團）。

Chihiro's mother, Fumie, retires from Tokyo Prefectural Sixth Girls' High School, becomes supervisor of the Greater Japan Federation of Girls' Youth Groups (later, Greater Japan Youth Organization).

1941 (22 years old)
於丈夫自殺後三月回國。以成為書法家為目標，再次跟隨小田周洋學習書法。
位于千代田／中野區（現在的本町附近）的新家落成。

Returns home in March after her husband commits suicide. Returns to study calligraphy under Shuyo Oda, aiming to become calligrapher.
Chihiro's parents build and move into a house in Chiyoda-cho Nakano-ku (near current-day Honcho).

於白骨溫泉寫生燒岳，1937
Painting Yakedake Mountains at Shirahone
Hot Springs (Chihiro at left), 1937

在森川照相館拍照，1938
Picture taken at Morikawa Photo Studio,
1938

於美軍司令部前，1944
In front of Unit Commander, 1944

1942　(23 years old)
師承中谷泰，再次開始學習油畫。
Returns to study oil painting under Tai Nakatani.

1944　(25 years old)
隨女子義勇隊和中谷泰、妹妹世史子等人一起前往黑龍江七台河市勃利縣。夏天因戰況惡化而回國。
In April, along with Tai Nakatani and sister Yoshiko, travels to Boli (in Heilongjiang Province, China) with a women's volunteer unit; returns home in summer due to deteriorating war situation. .

1945　(26 years old)
在東京中野的家因為空襲而被燒毀，因此疏散母親的娘家（長野縣松本市），在這裏迎來戰爭的結束。
House in Nakano, Tokyo, burns down in air raid in May; evacuates to grandmother's house in Matsumoto City, Nagano Prefecture, where she remains until end of war.

1946　(27 years old)
秋天，父母開始在長野縣北安曇郡松川村（現在的安曇野知弘美術館所在地）開荒。
在長野縣松本市加入日本共產黨，回到東京進入黨宣傳部興辦的藝術學校。
師承赤松俊子（丸木俊）。
成為「人民新聞」的寫作插畫家。
成為日本美術會成員。
Parents begin cultivating land in Matsukawa Village, Kita-azumi County, Nagano Prefecture, current site of the Chihiro Art Museum Azumino.
Becomes a member of the Japanese Communist Party in Matsumoto City, Nagano Prefecture. Returns to Tokyo to enter art school run by the Party's publicity department.
Studies art under Toshiko Akamatsu (also known as Toshi Maruki)
Becomes a writer-illustrator for the Jinmin Shinbun (People's Paper).
Becomes member of Nihon Bijutsu Kai (Japan Art Group) .

1947　(28 years old)
參加前衛美術協會的創立。
五月，畫了第一本單行本的插畫《壞狐狸雷內克》（出版：霞關書房）。
Participates in the foundation of the Zenei Bijutsu Kai (Avant-garde Art Group).
In May, illustrates her first book: "The Bad Fox: His Name is Reinecke" (published by Kasumigaseki Shobo).

1948　(29 years old)
成為日本兒童畫會成員。

與丈夫善明，1950
With her husband Zenmei, 1950

與丸木俊，1950
With Toshiko Akamatsu, 1950

於練馬區下石井新居，1951
At the site of new house in Shimo-shakujii,
Nerima Ward, 1951

為了報紙插圖、插畫、畫刊、教科書等工作手繪了許多畫，也包括油畫。
於此時決心成為獨立畫家。受日本民主主義文化聯盟所托，繪製連環畫
劇《母親的故事》。
租屋在神田鐵皮屋的二樓。
著迷於佛雷・亞斯坦的舞蹈，經常去看電影。

Becomes a member of Nihon Doga Kai (Japan Children's Picture Group)
Works on many newspaper clips, inserted illustrations, picture magazines,
and textbooks; often paints in oils as well.
At the request of Nihon Minshushugi Bunka Renmei (Japan Democratic
Cultural Association), illustrates "The Story of a Mother", "paper theater "
storytelling panels.
Around this time, decides to become an independent artist.
Takes lodgings on second floor of a tin shop in Kanda.
Becomes enamored with dancing of Fred Astaire; frequently goes to
movies.

1949 (30 years old)
參加日本共產黨的活動時，與松本善明相識。
Becomes acquainted with Zenmei Matsumoto through the activities of the
Japanese Communist Party.

1950 (31 years old)
和松本善明結婚。
1949 年教育連環畫劇研究會出版連環畫劇《母親的故事》，1950 年獲文
部大臣獎。
Marries Zenmei Matsumoto in January.
"The Story of a Mother" "paper theater " storytelling panels published
by Kyoiku Kamishibai Kenkyukai (Educational Picture-story-show Study
Group)in 1949, receives the Education Minister's Award.

1951 (32 years old)
長子猛出生。
因經濟因素，不得不將孩子寄養在長野縣松川村的父母家。這期間，為
了看望孩子，頻繁前往松川村且畫了許多素描。
Birth of son Takeshi in April.
For financial reasons, obliged to leave Takeshi in her parents' care in
Matsukawa Village, Nagano Prefecture from June; visits almost every
month Matsukawa Village to see her son, leaving numerous sketches.

1952 (33 years old)
東京都練馬區下石神井（現在的知弘美術館所在地）新居落成，一家三
口開始一起生活。之後 22 年間，在這裏進行創作活動。
為ヒゲタ醬油畫廣告。
Builds a house in Shimo-shakujii, Nerima-Ward, Tokyo, (where the Chihiro
Art .Museum Tokyo now stands); begins life there as a family of three;

知弘背著兒子猛於大阪車站月台，1954
Chihiro carrying her son Takeshi on her back
at Osaka Station platform, 1954

獲小學館兒童文化獎，1956
At the awards ceremony of the Juvenile
Culture Award of the Shogakukan
Publishing Co., 1956

知弘與兒子松本猛，1956
Chihiro and her son Takeshi leaning back to
back, 1956

continues to work at site for next 22 years.
Around this time, begins illustrating for Higeta Soy Sauce advertisements.

1953　(34 years old)
父親正勝過世。
Chihiro's father, Masakatsu, dies in January.

1954　(35 years old)
第 2 屆日本美展《戴眼罩的少女》（油畫）、童畫展《玉蟲廚子的故事》
（油畫）參展。
Participates in the 2nd Nippon (Japan) exhibition with "A Girl with an Eye-Patch" (in oils), and in the Doga exhibition with "The Story of the Tamamushi no Zushi" (Jewel Beetle Shrine) (in oils).

1956　(37 years old)
以畫刊等為作品的發表對象，獲小學館兒童文化獎。
作為繪本事業起點的創作《一個人也能做到》（福音館書店）。
Receives the Juvenile Culture Award from Shogakukan Publishing Co. for her work, including illustrations for picture magazines
Creates her first picture book, *Hitori de Dekiru yo* (I Can Do It All By Myself), (published by Fukuinkan Shoten)

1958　(39 years old)
開始為至光社的畫刊（月刊）《孩子們的世界》繪圖。
繪製連環畫劇《月亮幾歲了》（童心社），第二年獲厚生大臣獎。
Begins illustrating for the "Kodomo no Sekai" (Children's World) monthly picture magazine by Shiko-sha.
Illustrates the "What the Moon Saw", "paper theater" storytelling panels by Doshinsha; receives the Health Minister's Award the following year.

1960　(41 years old)
出版《識字書》（童心社），於次年獲產經兒童出版文化獎
Creates *AIUEO no Hon* (The Alphabet Book: A-I-U-E-O), published by Doshinsha; wins the Sankei Children's Books and Culture Award the following year.

1962　(43 years old)
人生最後一幅油畫作品，《孩子》。
針對教科書中插畫重複使用的問題，與太田大八，久保雅勇等一起抗議，
並頑強地堅持到最終解決。
Paints her last oil work, "Kodomo" (Child)
Along with Daihachi Ota, Masao Kubo and others, protests against reuse of their textbook illustrations, putting up a tenacious fight until the issue is resolved.

手持素描本，1960
Holding her sketchbook, 1960

1963 (44 years old)

為《孩子的幸福》雜誌（草土文化）繪製封面畫，直至 1974 年 8 月號為止，知弘的畫一直作為封面使用。

3 月，與赤羽末吉，遠藤輝代，柿本幸造，中尾彰，渡邊三郎，丸井俊等組成「白牆組合」。

擴建石神井的住宅和工作室，與丈夫善明的父母一起居住。

至莫斯科參加世界婦女大會。

Begins illustrating front covers of the magazine "Kodomo no Shiawase" (Children's Happiness), a publication of Sodo-Bunka; Chihiro's illustrations continue to grace the magazine's covers until its August 1974 issue.

In March, forms the "Group Kabe(Walls)" with Suekichi Akaba, Teruyo Endo, Kozo Kakimoto, Akira Nakao, Saburo Watanabe, Toshi Maruki, and others.

Extensions built to the Shimo-shakujii residence and studio to live with her husband Zenmei's parents.

In June, attends the Women's International Conference held in Moscow.

1964 (45 years old)

和安泰、遠藤輝代、久米宏一、瀧平二郎、東本恆、箕田源二郎等人集結成《童畫集中車》。

8 月，日本童書畫家協會成立。

作為董事會成員，積極爭取保護畫家的版權。

Forms the "Doga Group Kuruma(Cars)" with Tai Yasu, Teruyo Endo, Koichi Kume, Jiro Takidaira, Tsune Tomoto, Genjiro Mita, and others.

In August, Japan Children's Book Artists Society (Dobiren) inaugurated

As executive board member, continues active involvement in copyright protection.

1965 (46 years old)

出版《龍的眼淚》（偕成社）、《話說安徒生》（童心社）

Ryu no Me no Namida (The Tears of the Dragon) published by Kaisei-sha; *Ohanashi Anderusen* (Hans Christian Andersen Stories) published by Doshin-sha.

1966 (47 years old)

和畫家朋友與母親文江一起去歐洲旅行。

回國後開始為安徒生童話《月亮看見了》繪圖（童心社）。

長野縣黑姬高原上的住所落成後，之後每年都會來到這進行繪本創作。

出版《拇指姑娘》（講談社）、《白鶴報恩》（偕成社）。

Travels in Europe with her artist friends and her mother, Fumie.

Returning home, illustrates H.C. Andersen's *What the Moon Saw* published by Doshin-sha.

Builds a lodge in Kurohime Heights, Nagano Prefecture; produces picture

與丈夫善明於庭園，1968
With her husband Zenmei in their garden, 1968

books at this site every year thereafter
Thumbelina published by Kodansha and The Crane's Reward published by Kaisei-sha.

1967　(48 years old)
創作《我還小的時候》（童心社）。
丈夫善明當選眾議院議員。
出版《白雪公主》（講談社）、《聰明的王妃》（講談社）、《人魚公主》（偕成社）、《浦島太郎》（偕成社）。
Illustrates *When I Was a Child,* published by Doshin-sha.
Husband Zenmei is elected to the House of Representatives.
Snow White and *The Wise Queen* published by Kodansha; *The Little Mermaid* and *Urashima Taro* (The Dragon Palace) published by Kaisei-sha.

1968　(49 years old)
運用「用畫面講話的繪本」創作理念的最初嘗試之作《下雨天一個人在家》（至光社）。
之後，與至光社和武市八十雄一起合作創作繪本。
創作自傳性質的繪本《我的圖畫書》（綠書房，即現在的新日本出版社）
出版《天鵝湖》（講談社）、《紅氣球》（偕成社）、《紅鞋子》（偕成社）《愛是無限的—十二月黨人的致妻書》。
Ame no Hi no Orusuban (Staying Home Alone on a Rainy Day) created this year and published by Shiko-sha; artist's first attempt to create a book told largely in pictures; subsequently active in picture book production for Shiko-sha, along with Yasoo Takeichi.
Creates autobiographical picture book *Watashi no Ehon* (My Picture Book), published by *Midori Shobo* (now Shinnihon Shuppan-sha)
Swan Lake, published by Kodansha; *The Red Balloon,* and *The Red Shoes published* by Kaisei-sha; *Ai Kagirinaku* (Unlimited Love) published by Doshin-sha.

1969　(50 years old)
創作《鬼太的帽子》（ポプラ社）、《花的童話集》（童心社）等。
出版《兩個人的舞會》（講談社）、《青鳥》（講談社）、《鯉魚村》（新日本出版社）。
Creates *Onita no Boshi* (Onita's Hat) published by Poplar-sha; *Hana no Dowa Shu* (Flower Fairy Tales) published by Doshin-sha.
Futari no Butoukai (Dance for Two) and *The Blue Bird* published by Kodansha; *Koi no Iru Mura* (A Village with Carp) published by Shinnihon Shuppan-sha.

1970　(51 years old)
創作彩粉畫繪本《隔壁家的北子》（至光社）。
現存的彩粉畫幾乎都是 1970 年創作的。
出版《寶寶的明天》（至光社）、《洗澡啦，嘩啦嘩啦》（童心社）《喂

知弘於畫室作畫，1971
Chihiro painting in her atelier, 1971

知弘與她的狗，1971
At her studio with her dog, 1971

與家人於家中，1971
On the veranda of her home with her family, 1972

喂喂 打電話》（童心社）《萬葉集》（童心社）、《彩虹湖》（偕成社）在「支援越南兒童協會」主辦的街頭展覽上展出作品。
將中風的媽媽帶到位於石神井的家照顧。

Creates pastel illustrations for *Tonari ni Kita Ko* (Will You Be My Friend?) published by Shiko-sha.

Most of the artist's currently existing pastel drawings date from this year.

Akachan no Kuru Hi (A New Baby Is Coming to My House) published by Shiko-sha; *Ofuro de Chapu Chap* (I Love Bathing), *Moshi Moshi Odenwa* (The Phone is Ringing), and *Manyo no Uta* (Verses of "Ten Thousand Leaves," the oldest anthology of Japanese poetry) all published by Doshin-sha; *Niji no Mizuumi* (Rainbow over the Lake) published by Kaisei-sha.

Participates in street exhibition organized by the Association to Help the Children of Vietnam.

Takes mother, who suffered cerebral thrombosis the previous year, into her care at her Shakujii home.

1971 (52 years old)

這期間患上了十二指腸潰瘍。
出版《隔壁家的北子》（至光社）、《小寶寶的歌》（童心社）、《誰長得高》（童心社）、《雪怪的禮物》（新日本出版社）。

Tonari ni Kita Ko (Will You Be My Friend? Child's Play) published by Shiko-sha; *Akachan no Uta* (Songs for Babies) and *Takekurabe* (Child's Play) published by Doshin-sha; *Yukigon no Okurimono* (The Snowman's Present)" published by Shinnihon Shuppansha.

Around this time, begins suffering from duodenal ulcer.

1972 (53 years old)

出版《小鳥來的那一天》（至光社），1973年獲波隆那國際兒童圖書展插畫獎。
創作《久兒之星》（岩崎書店）、《下雪天的生日》（至光社）、《媽媽不在家》（新日本出版社）。開始創作《戰火中的孩子》。
夏天住進代代木醫院。

Kotori no Kuru Hi (The Pretty Bird) published by Shiko-sha; wins the Graphic Prize Fiera di Bologna, the following year.

Illustrates *Hisa no Hoshi* (Hisa's Star), published by Iwasaki Shoten; *Kaasan wa Orusu* (Mother Is Not at Home), published by Shinnihon Shuppansha; *Akamanma Toge* (The Akamanma Pass) published by Doshin-sha; begins creating *Senka no Naka no Kodomo-tach* (Children in the Flames of War).

Admitted to Yoyogi Hospital in summer.

1973 (54 years old)

3月在夏威夷休養。
創作《波奇到海邊》（至光社），完成並出版《戰火中的孩子們》（岩崎書店），第二年獲萊比錫國際書展銅獎。
《孩子的幸福》雜誌（草土文化）封面畫結集出版，書名《孩子的幸福

獲波隆納國際兒童圖書展獎，1973
In celebration of winning the Graphic Prize
Fiera di Bologna, 1973

於家中，1973
At home, 1973

畫集》。

因癌症在代代木醫院住院，稍好一些後出院

出版《赤飯嶺》（童心社）、《狐狸的路是通往天國的路》（大日本圖書）。

Convalescence in Hawaii in March

Yuki no Hi no Tanjobi (Snowy Birthday), published by Shiko-sha;
Illustrates Pochi no Kita Umi (What's Fun without a Friend?), published by Shikosha the following year; completes *Senka no Naka no Kodomo-tachi* (Children in the Flames of War) published by Iwasaki Shoten; granted bronze medal of the Leipzig International Book Fair the following year.

Series of cover illustrations for the magazine "Kodomo no Shiawase" (Children's Happiness) published by Sodo-Bunka, compiled into a book of illustrations entitled *Kodomo no Shiawase Gashu* published by Iwanami Shoten.

Admitted with cancer to Yoyogi Hospital in autumn; later discharged from the hospital, in remission.

Kitsune Michi wa Ten no Michi (A Path of Foxes Is a Path to Heaven) published by Dainippon-tosho.

1974 (55 years old)

3 月因病情惡化再度入院。

6，月創作了關於小寶寶的畫，這是她的遺作。

因原發性肝癌去世，享年 55 歲。

In March, readmitted to hospital due to worsening health .

In June, draws eyes for the picture of a baby which becomes her final work before the artist's death.

On August 8, died of primary liver cancer.

1975

未完成的遺作《紅蠟燭和人魚》（童心社）出版。

Unfinished work *Akai Rosoku to Ningyo* (The Red Candles and the Mermaid) published posthumously by Doshin-sha.

1977

在練馬區石神井宅邸原址，岩崎知弘繪本美術館（現在的知弘美術館東京館）開館。

In September, Chihiro Iwasaki Art Museum of Picture Books (currently Chihiro Art Museum Tokyo) opens its doors on the site of the artist's home in Shakujii, Nerima-Ward, Tokyo.

1997

安曇野知弘美術館於長野縣北安曇野鄉松川村開館。

In April, Chihiro Art Museum Azumino opens its doors in Matsukawa Village, Kita-azumi District, Nagano Prefecture.

年份	圖像	作品名	材質
Last 1940s		自畫像 (約 30 歲) Self-Portrait (around age 30)	鉛筆、紙 Pencil on Paper 256 × 182mm
1946.12.14		火車上的乘客 Train Passengers	鉛筆、紙 Pencil on Paper 296 × 209mm
1947		井手則雄畫像 Portrait of Norio Ide	炭精筆、紙 Conté on Paper 296 × 206mm
1949.05.11		悠閒閱讀中的女孩 Girl Relaxing While Reading a Book	鉛筆、紙 Pencil on Paper 174 × 139mm
1952		老婦人畫像 Portrait of an Old Woman	鉛筆、紙 Pencil on Paper
1954.10.30		裸女 Nude Woman	鉛筆、炭精筆、紙 Pencil, Conté on Paper 357 × 251mm
1963.06.20		列寧格勒的冰淇淋攤 Ice Cream Stand in Leningrad	鉛筆、水彩、紙 Pencil, Watercolor on Paper 152 × 200mm
1963.07		貝加爾湖 Lake Baikal	鉛筆、水彩、紙 Pencil, Watercolor on Paper 145 × 204mm

索引 Index　　　**I** 岩崎知弘的生命旅程 Life of Chihiro Iwasaki

年份	圖像	作品名	材質
1966.03.30		丹麥歐登塞安徒生之家 The Andersen's Home, Odense	鉛筆、水彩、紙 Pencil, Watercolor on Paper 160 × 235mm
1966.04		從亞眠到盧昂的火車上 In the Train from Amiens to Rouenn	鉛筆、水彩、紙 Pencil, Watercolor on Paper
1966.04.04		速寫在盧昂市街角的男子 A Man Drawing on a Street Corner	鉛筆、水彩、紙 Pencil, Watercolor on Paper 235 × 160mm
1971.04.03		長谷寺的櫻桃樹 Cherry Trees at Hase Temple	鉛筆、水彩、紙 Pencil, Watercolor on Paper 181 × 245mm
1971.04.03		長谷寺附近 Near the Hase Temple	鉛筆、水彩、紙 Pencil, Watercolor on Paper 181 × 244mm
1973.03.25		日落威基基海 Sea at Sunset, Waikiki	鉛筆、水彩、紙 Pencil, Watercolor on Paper 182 × 262mm

年份	圖像	作品名	材質
Late 1960s		穿橘色洋裝的女孩與魚 Girl in Orange Dress with Fish	鉛筆、水彩、紙 Pencil, Watercolor on Paper 482 × 358mm
Late 1960s		暖爐與兩個孩子 Stove and Two Children 《腳步》第 10 號，生活之友社 "Steps", Seikatsu no Tomo-sha, n.10	鉛筆、水彩、紙 Pencil, Watercolor on Paper 226 × 348mm
1965		鬱金香叢中的男孩 Boy among Tulips 《孩子們的世界》1966 年 4 月，至光社 "Children's World", Shiko-sha, April, 1966	鉛筆、水彩、紙 Pencil, Watercolor on Paper 318 × 318mm
1966		蘑菇與撐著傘的男孩 Mushrooms and Boy with Umbrella 《孩子們的世界》1966 年 10 月，至光社 "Children's World", Shiko-sha, October, 1966	鉛筆、水彩、紙 Pencil, Watercolor on Paper 288 × 292mm
1969		罌粟花與孩子 Poppies and a Child 日曆，1970 年 4、5、6 月 Calendar for April, May, June, 1970	鉛筆、水彩、紙 Pencil, Watercolor on Paper 595 × 210mm
1969		魚與曬黑的孩子們 Fish and Suntanned Children 日曆，1970 年 Calendar for 1970	水彩、紙 Watercolor on Paper 455 × 282mm
1969		秋天草堆中的女孩 Girl among Autumn Grass 日曆，1970 年 10 月 Calendar for October, 1970	鉛筆、水彩、紙 Pencil, Watercolor on Paper 484 × 361mm
1969		滑雪的男孩 Boy Skiing 日曆，1970 年 Calendar for 1970	水彩、紙 Watercolor on Paper 483 × 359mm

年份	圖像	作品名	材質
1969		女孩與紙娃娃 Girl with Paper Dolls 日曆，1970 年 Calendar for 1970	鉛筆、水彩、紙 Pencil, Watercolor on Paper 484 × 359mm
1970		小男孩拿著貝殼靠近耳邊 Boy Holding a Shell to His Ear 《孩子們的世界》1970 年 7 月，至光社 "Children's World", Shiko-sha, July, 1970	鉛筆、水彩、紙 Pencil, Watercolor on Paper 385 × 305mm
1970		孩童們與春天的花朵 Children and Spring Flowers 日曆，1971 年 4、5、6 月 Calendar for April, May, June, 1971	鉛筆、水彩、紙 Pencil, Watercolor on Paper 285 × 202mm
1970		穿比基尼的女孩 Girl in a Bikini 日曆，1971 年 Calendar for 1971	粉彩、紙 Pastel on Paper 500 × 649mm
1970		在雪中奔跑的孩子 Child Running in Snow 《孩子的幸福》1971 年 1 月，草土文化 "Children's Happiness", Sodo-Bunka, January, 1971	鉛筆、水彩、紙 Pencil, Watercolor on Paper 241 × 201mm
1971		在爐邊抱著貓的女孩 Girl Hugging Her Cat by the Fireside 《孩子們的世界》1972 年 2 月，至光社 "Children's World", Shiko-sha, February, 1972	水彩、紙 Watercolor on Paper 357 × 345mm
1971		紅蜻蜓與男孩 Red Dragonflies and Boy 日曆，1972 年 9、10 月 Calendar for September, October, 1972	鉛筆、水彩、紙 Pencil, Watercolor on Paper 482 × 358mm
1972		女孩與柿子 Girl and Persimmons 《孩子的幸福》1972 年 10 月，草土文化 "Children's Happiness", Sodo-Bunka, October, 1972	鉛筆、水彩、紙 Pencil, Watercolor on Paper 242 × 180mm

年份	圖像	作品名	材質
1972		藍色的鳥、花、以及孩子 Blue Flowers, Birds and Child 《孩子的幸福》1972 年 4 月，草土文化 "Children's Happiness", Sodo-Bunka, April, 1972	鉛筆、水彩、紙 Pencil, Watercolor on Paper 359 × 241mm
1972		男孩與橡樹果 Boy and Acorns 《孩子們的世界》1972 年 10 月，至光社 "Children's World", Shiko-sha, October, 1972	水彩、紙 Watercolor on Paper 359 × 300mm
1973		女孩與香豌豆花 Girl and Sweetpeas 《孩子的幸福》1973 年 9 月，草土文化 "Children's Happiness", Sodo-Bunka, September, 1973	水彩、紙 Watercolor on Paper 358 × 326mm
1973		海邊的向日葵、女孩與小狗 Sunflowers,Girl, and Her Puppy at the Shore 習作《波奇到海邊》，至光社 Study for *What's Fun without a Friend?*, Shiko-sha	水彩、紙 Watercolor on Paper 386 × 545mm

年份	圖像	作品名	材質
1954		肥皂泡泡 Soap Bubbles 《好孩子王國》1954 年 7 月，學習研究社 "Kingdom of Good Child", Gakushu Kenkyu-sha, July, 1954	水彩、紙 Watercolor on Paper 263 × 173mm (left), 268 × 184 (right)
1958		「飄起小雪」 "Light Snow Falling" 《好孩子王國》1958 年 12 月，學習研究社 "Kingdom of Good Child", Gakushu Kenkyu-sha, December, 1958	水彩、紙 Watercolor on Paper 208 × 370mm
1958		躲雨 Getting out of the Rain 《孩童書》1958 年 6 月，福祿貝爾館 "Kinder Book", Froebel-Kan, June, 1958	水彩、紙 Watercolor on Paper 314 × 431mm
1958		「春天」 "Spring" 《好孩子王國》1959 年 7 月 x 學習研究社 "Kingdom of Good Child", Gakushu Kenkyu-sha, March, 1959	水彩、紙 Watercolor on Paper 353 × 483mm
1961		積木遊戲 Children Building with Wood 《孩童書》1961 年 7 月，福祿貝爾館 "Kinder Book", Froebel-Kan, July, 1961	鉛筆、水彩、紙 Pencil, Watercolor on Paper 337 × 446mm
1963		「扮家家酒」 "Playing House" 《孩童書》1964 年 4 月，福祿貝爾館 "Kinder Book", Froebel-Kan, April, 1964	水彩、色鉛筆、鉛筆、紙 Watercolor, Crayon, Pencil on Paper 382 × 545mm
1963		彩虹橋 Rainbow Bridge 《孩子的書》1963 年 6 月，兒童社 "Child Book", Child-sha, June, 1963	水彩、紙 Watercolor on Paper 385 × 543mm
ca. 1965		孩童們與春天的花朵 Children and Spring Flowers	鉛筆、水彩、紙 Pencil, Watercolor on Paper 670 × 717mm

年份	圖像	作品名	材質
1958		綁辮子的女孩吃午餐 Girl in Braids Eating Lunch 報紙廣告 Advertisement for Newspaper	鉛筆、紙 Pencil on Paper 253 × 175mm
1966		在教室裡的孩子們 Children in Their Classroom 習作《家庭教育 3 少年期》1966 年，岩波書店 Study for: "Education at Home 3: Teenage Years", Iwanami-shoten, 1966	鉛筆、墨水 Pencil, Chinese Ink on Paper 122 × 156mm
1966		背著書包排隊的一年級學生 First Graders with Satchels Walking in Single File	水彩 Watercolor 167 × 291 mm
1968		女孩凝視著花朵 Girl Gazing at a Flower 《孩子的幸福》1968 年 4 月，草土文化 "Children's Happiness", Sodo-Bunka, April, 1968	鉛筆、紙 Pencil on Paper 267 × 185mm
1969		大鳥與小鳥 Large Bird and Small Bird	水彩、紙 Watercolor on Paper 381 × 539 mm
1969		春日庭園 Spring Garden 日曆，1970 年 4 月 Calendar, April 1970	鉛筆、水彩、紙 Pencil, Watercolor on Paper 484 × 333mm
1969		孩童看得目不轉睛 Children Gazing 《孩子的幸福》1969 年 4 月，草土文化 "Children's Happiness", Sodo-Bunka, April, 1969	鉛筆、紙 Pencil on Paper 242 × 180mm
Early 1970s		戴棕帽的女孩 Girl Wearing a Brown Hat	鉛筆、水彩、紙 Pencil, Watercolor on Paper 210 × 90 mm

年份	圖像	作品名	材質
Early 1970s		戴淡紫色帽子的女孩 Girl with Mauve Hat	水彩、紙 Watercolor on Paper 193 × 149 mm
1970		穿粉紅毛衣的女孩 Girl in Pink Sweater	粉彩、水彩、紙 Crayon, Watercolor on Paper 482 × 358mm
1970		孩子們在春日田野間玩「剪刀、石頭、布」 Children Playing "Paper, Scissors, Rock,"in a Field of Spring 小學課外讀物，日本書齋 Elementary School Social Studies Sub-textbook: Taro and Hanako, Nihon Shoseki	鉛筆、水彩、紙 Pencil, Watercolor on Paper 241 × 357mm
1970		穿粉紅洋裝的女孩 Girl in Pink Dress	粉彩、紙 Pastel on Paper 357 × 242mm
1971		小女孩與男孩捧鍋子 Girl with Boy Holding a Pot	鉛筆、水彩、紙 Pencil, Watercolor on Paper 357 × 247mm
1973		女孩與蒲公英 Girl with Dandelions 《孩子們的世界》1973 年 5 月，至光社 "Children's World", Shiko-sha, May, 1973	水彩、紙 Watercolor on Paper 483 × 358mm

年份	圖像	作品名	材質
1966		夕陽下的女孩與白鶴 The Girl and the Crane in the Sunset 《白鶴報恩》，偕成社 *The Crane's Reward*, Kaisei-sha	鉛筆、水彩、紙 Pencil, Watercolor on Paper 333 × 241mm
1966		鶴姑娘於下雪天翩然而至 The Maiden Arrives on a Snowy Day 《白鶴報恩》，偕成社 *The Crane's Reward*, Kaisei-sha	粉彩、紙 Pastel on Paper 356 × 483mm
1966		老翁解救白鶴 The Old Man Saving the Crane's Life 《白鶴報恩》，偕成社 *The Crane's Reward*, Kaisei-sha	鉛筆、水彩、紙 Pencil, Watercolor on Paper 356 × 483 mm
1966		白鶴展翅 The Crane Weaving 《白鶴報恩》，偕成社 *The Crane's Reward*, Kaisei-sha	鉛筆、水彩、紙 Pencil, Watercolor on Paper 360 × 482mm
1966		拇指姑娘從花中誕生 Thumbelina, Born out of a Flower 《拇指姑娘》，光之國昭和出版社 Thumbelina, Hikari no Kuni Showa-shuppan	鉛筆、水彩、紙 Pencil, Watercolor on Paper 356 × 484mm
1966		拇指姑娘與田鼠婆婆 Thumbelina and the Field Mouse Lady 《拇指姑娘》，光之國昭和出版社 Thumbelina, Hikari no Kuni Showa-shuppan	鉛筆、水彩、紙 Pencil, Watercolor on Paper 356 × 484mm
1966		田鼠婆婆、鼴鼠與受傷的燕子 Thumbelina, the Mole, and the Wounded Swallow 《拇指姑娘》，光之國昭和出版社 Thumbelina, Hikari no Kuni Showa-shuppan	鉛筆、水彩、紙 Pencil, Watercolor on Paper 357 × 484mm
1966		拇指姑娘與王子 Thumbelina and the Flower Prince 《拇指姑娘》，光之國昭和出版社 Thumbelina, Hikari no Kuni Showa-shuppan	鉛筆、水彩、紙 Pencil, Watercolor on Paper 357 × 484mm

年份	圖像	作品名	材質
1966		男人想像月亮看見什麼 The Man Imagining What the Moon Saw 《沒有畫的畫冊》，童心社 *Picture Book without Pictures*, Doshin-sha	鉛筆、墨水、紙 Pencil, Chinese Ink on Paper 204 × 125mm
1966		演技不佳的演員 Incompetent Actor 《沒有畫的畫冊》，童心社 *Picture Book without Pictures*, Doshin-sha	鉛筆、墨水、紙 Pencil, Chinese Ink on Paper 210 × 179mm
1966		坐在欄杆上的中國女孩 Chinese Girl Sitting on the Railing 《沒有畫的畫冊》，童心社 *Picture Book without Pictures*, Doshin-sha	鉛筆、墨水、紙 Pencil, Chinese Ink on Paper 212 × 179 mm
1966		小女孩在床上與母親一起禱告 Little Girl Praying in Bed with Her Mother 《沒有畫的畫冊》，童心社 *Picture Book without Pictures*, Doshin-sha	鉛筆、墨水、紙 Pencil, Chinese Ink on Paper 210 × 186 mm
1969		戴草帽的鬼太 Onita wearing a Straw Hat 《鬼太的帽子》，白樺社 *Onita's Hat*, Poplar-sha	鉛筆、水彩、紙 Pencil, Watercolor on Paper 360 × 484mm
1969		鬼太到廚房去察看 Onita Looking into the Kitchen 《鬼太的帽子》，白樺社 *Onita's Hat*, Poplar-sha	鉛筆、水彩、紙 Pencil, Watercolor on Paper 358 × 484mm
1969		走在雪中的鬼太 Onita Walking in the Snow 《鬼太的帽子》，白樺社 *Onita's Hat*, Poplar-sha	鉛筆、水彩、紙 Pencil, Watercolor on Paper 359 × 483 mm
1969		拿著水盆的女孩 The Girl Holding a Washbowl 《鬼太的帽子》，白樺社 *Onita's Hat*, Poplar-sha	鉛筆、水彩、紙 Pencil, Watercolor on Paper 359 × 482mm

年份	圖像	作品名	材質
1969		站在門邊的鬼太 Onita Standing at the Door 《鬼太的帽子》，白樺社 *Onita's Hat*, Poplar-sha	鉛筆、水彩、紙 Pencil, Watercolor on Paper 361 × 484mm
1969		鬼太給女孩紅豆飯 Onita Giving the Girl Cooked Rice with Red Beans 《鬼太的帽子》，白樺社 *Onita's Hat*, Poplar-sha	鉛筆、水彩、紙 Pencil, Watercolor on Paper 361 × 484mm
1970		小女孩打電話 The Girl Calling 《鈴鈴鈴，電話響了》，童心社 *Ring, Ring the Phone Rings*, Doshin-sha	鉛筆、水彩、紙 Pencil, Watercolor on Paper 262 × 484mm
1970		鴨子講電話 The Duck Talking on the Telephone 《鈴鈴鈴，電話響了》，童心社 *Ring, Ring the Phone Rings*, Doshin-sha	鉛筆、水彩、紙 Pencil, Watercolor on Paper 262 × 371mm
1970		蒲公英電話亭 The Dandelion's Telephone Office 《鈴鈴鈴，電話響了》，童心社 *Ring, Ring the Phone Rings*, Doshin-sha	鉛筆、水彩、紙 Pencil, Watercolor on Paper 269 × 396mm
1970		散步 Taking a Walk 《鈴鈴鈴，電話響了》，童心社 *Ring, Ring the Phone Rings*, Doshin-sha	鉛筆、水彩、紙 Pencil, Watercolor on Paper 265 × 485mm
1972		手上綁著繃帶的久兒 Hisa with Her Hand Bandaged 《兒之星》，岩崎書店 *Hisa's Star*, Iwasaki-shoten	鉛筆、水彩、紙 Pencil, Watercolor on Paper 360 × 355mm
1972		溪水暴漲 Rising River 《兒之星》，岩崎書店 *Hisa's Star*, Iwasaki-shoten	水彩、紙 Watercolor on Paper 358 × 482mm

V 圖畫書選粹 Picture Books

年份	圖像	作品名	材質
1972		久兒追趕小吉 Hisa Running after Masakichi 《兒之星》，岩崎書店 *Hisa's Star*, Iwasaki-shoten	水彩、紙 Watercolor on Paper 359 × 483mm
1972		村民划船找尋久兒 The Village People on a Boat Searching for Hisa 《兒之星》，岩崎書店 *Hisa's Star*, Iwasaki-shoten	鉛筆、水彩、紙 Pencil, Watercolor on Paper 190 × 265mm
1972		男人凝視暗處 A Man Staring into the Darkness 《兒之星》，岩崎書店 *Hisa's Star*, Iwasaki-shoten	鉛筆、水彩、紙 Pencil, Watercolor on Paper 339 × 482mm
1972		生日派對 The Birthday Party 《下雪的生日》， 首次發表於《孩子們的世界》1973 年 1 月，至光社 *Snowy Birthday*, First appeared in : "Children's World", Shiko-sha, January, 1973	鉛筆、水彩、紙 Pencil, Watercolor on Paper 386 × 545mm
1972		小女孩吹蠟燭 The Girl Who Blew Out Candles by Mistake 《下雪的生日》， 首次發表於《孩子們的世界》1973 年 1 月，至光社 *Snowy Birthday*, First appeared in : "Children's World", Shiko-sha, January, 1973	鉛筆、水彩、紙 Pencil, Watercolor on Paper 385 × 648mm
1972		夕陽下的女孩 The Girl at Sunset 《下雪的生日》， 首次發表於《孩子們的世界》1973 年 1 月，至光社 *Snowy Birthday*, First appeared in : "Children's World", Shiko-sha, January, 1973	鉛筆、水彩、紙 Pencil, Watercolor on Paper 362 × 544 mm
1972		被白雪覆蓋的屋舍 The Snow-covered Houses 《下雪的生日》， 首次發表於《孩子們的世界》1973 年 1 月，至光社 *Snowy Birthday*, First appeared in : "Children's World", Shiko-sha, January, 1973	水彩、紙 Watercolor on paper 384 × 544 mm
1972		戴紅色羊毛帽的女孩 The Girl Wearing a Red Woolen Cap 《下雪的生日》， 首次發表於《孩子們的世界》1973 年 1 月，至光社 *Snowy Birthday*, First appeared in : "Children's World", Shiko-sha, January, 1973	鉛筆、水彩、紙 Pencil, Watercolor on Paper 327 × 361mm

年份	圖像	作品名	材質
Late 1960s		寶寶走向姊姊 Baby Walking towards His Big Sister	水彩、紙 Watercolor on Paper 366 × 484 mm
1970		「願全世界的孩子都平和喜樂」 "Wishing Peace and Happiness for All the Children of the World" 為越戰兒童救援協會繪製之海報 Poster Drawn for Association to Help the Children of Vitenam	粉彩、紙 Pastel on Paper 1035 × 730mm
1971		大姊姊與小弟弟 Big Sister and Her Baby Brother 海報 Poster	鉛筆、水彩、紙 Pencil, Watercolor on Paper 243 × 318mm
1971		寶寶與蝴蝶 Baby and Butterflies 海報 Poster	鉛筆、水彩、紙 Pencil, Watercolor on Paper 180 × 120mm
1971		粉紅兔子與寶寶 Pink Rabbit and Baby 海報 Poster	鉛筆、水彩、紙 Pencil, Watercolor on Paper 179 × 241mm
1971		鬱金香花叢中的寶寶 Baby among Tulips 海報 Poster	鉛筆、水彩、紙 Pencil, Watercolor on Paper 357 × 430mm
1971		寶寶、鴨子和泰迪熊 Baby, Duck and Teddy Bear 海報 Poster	鉛筆、水彩、紙 Pencil, Watercolor on Paper 241 × 234 mm
1973		在兔耳花叢中的孩子 Children among Cyclamen Flowers 《戰火中的孩子》，岩崎書店 Children in the Flames of War, Iwasaki-shoten	鉛筆、水彩、紙 Pencil, Watercolor on Paper 359 × 484mm

年份	圖像	作品名	材質
1973		男孩 Boy 《戰火中的孩子》，岩崎書店 *Children in the Flames of War*, Iwasaki-shoten	鉛筆、水彩、紙 Pencil, Watercolor on Paper 357 × 364mm
1973		受傷的孩子 Wounded Children 《戰火中的孩子》，岩崎書店 *Children in the Flames of War*, Iwasaki-shoten	鉛筆、墨水、紙 Pencil, Chinese Ink on Paper 385 × 545 mm
1973		環視角落的女孩 Girl Looking around the Corner 《戰火中的孩子》，岩崎書店 *Children in the Flames of War*, Iwasaki-shoten	鉛筆、紙 Pencil on Paper 452 × 360 mm
1973		躲在空襲避難所的孩子們 Children in Air-raid Shelter 《戰火中的孩子》，岩崎書店 *Children in the Flames of War*, Iwasaki-shoten	鉛筆、墨水、紙 Pencil, Chinese Ink on Paper 452 × 360 mm

知弘美術館介紹

About Chihiro Art Museum Tokyo & Azumino

知弘美術館介紹

About Chihiro Art Museum Tokyo & Azumino

知弘美術館 · 東京　美術館外觀 / 拍攝：中川敦玲
Chihiro Art Museum Tokyo; Exterior of a building / Photograph by Nobuaki Nakagawa

知弘美術館介紹

　　知弘美術館 · 東京（原為岩崎知弘繪本美術館）成立於 1977 年，以紀念日本藝術家岩崎知弘（1918-1974），建立在知弘自 1952 年至 1974 年去世前居住和工作的地點。

　　在知弘美術館 · 東京，為了保護及保存這些纖細的作品，又能讓來館參觀的訪客盡興而歸，每兩個月就會更換不同的展覽主題。美術館除了展示知弘作品及國際精選繪本，也為不同年齡層的觀眾提供各種展示類型。而知弘的畫室也逼真的重現於此，她所喜愛的花草也盛開在「知弘的花園」裡。

　　1997 年春，為了紀念知弘美術館 · 東京成立二十週年，長野縣安曇野知弘美術館正式啓用。由於知弘的父母來自長野，所以她對這個地區相當熟悉，感情深厚且視其為心靈家園。除了展示岩崎知弘的畫作外，常設展品包括國際收藏的精選作品以及有關繪本演進史的展示。在安曇野美術館周圍有一個 5 萬 3500 平方米的公園，參觀者可以看到知弘的畫室重現，還有捷克藝術家 Kvĕta Pacovská 的石頭與池塘設計，以及最近開放的小荳荳公園。

https://chihiro.jp/

知弘美術館・東京　知弘的畫室　拍攝：嶋本麻利沙
Chihiro Art Museum Tokyo; Atelier / Photogragh by Marisa Shimamoto

The Chihiro Art Museum Tokyo (formerly Chihiro Iwasaki Art Museum of Picture Books) was established in 1977 to commemorate Chihiro Iwasaki. The Museum was built on the site where Chihiro lived and worked from 1952 until her death in 1974.

At the Chihiro Art Museum Tokyo, exhibitions are organized according to various themes and are rotated every two months for visitors' enjoyment and to protect and conserve the delicate artwork. In addition to exhibitions featuring selections from the Chihiro Iwasaki Collection and International Collection, the Museum features shows of various art genres for visitors of all ages. The artist's atelier has also been restored and now accurately conveys the appearance it assumed when Chihiro worked there. In "Chihiro's Garden" you will be greeted by the same flowers and plants that Chihiro loved and tended to in her own garden.

The Chihiro Art Museum Azumino, which opened its doors in 1997, in commemoration of the twentieth anniversary of the establishment of the Chihiro Art Museum Tokyo, is located in Nagano Prefecture. As Chihiro's parents were both from Nagano, Chihiro was very familiar with the region and held a deep affection for it as her spiritual home. In addition to displays of artwork by Chihiro Iwasaki, regular exhibits include selections from the International Collection and a display focusing on the history of picture book illustrations.

Surrounding the museum, is a 535,00-square-meter park where visitors can see Chihiro's restored studio along with the Stone Project and Ponds designed by Czech artist Květa Pacovská as well as the recently opened Totto-chan park.

安曇野知弘美術館　展覧室
Chihiro Art Museum Azumino; Exhibit room

安曇野知弘美術館　美術館外観
Chihiro Art Museum Azumino; Exterior of a building

童·樂

岩崎知弘經典插畫展

Chihiro Iwasaki Exhibition
Children in the World : Peace and Happiness for All

2018/02/01-2018/04/22 國立歷史博物館
10:00-18:00｜週一及除夕閉館
2018/02/01-2018/04/22 im National Museum of History
Tuesday-Sunday 10:00-18:00 Closed on Mondays and Chinese New Years' Eve

主辦單位	國立歷史博物館、知弘美術館、蔚龍藝術有限公司
協辦單位	閣林文創、童書作家與插畫家協會臺灣分會、親子天下、國立臺東大學兒童文學研究所
協力媒體	三立新聞網、城市美學新態度、瘋設計
發行人	王玉齡
策展人	上島史子、松方路子
策展團隊	知弘美術館：竹迫祐子、上島史子、松方路子
	國立歷史博物館：江桂珍、林瑞堂、吳昭潔
	蔚龍藝術：王玉齡、鄭如芳、吳宣頤、陳志芳、趙曼鈞、毛瑞馨、李紅逸、林律嘉、王煜傑
文字撰述	上島史子、原島惠、松方路子
學術顧問	游珮芸
企畫編輯	鄭如芳、吳宣頤、毛瑞馨、李紅逸
設計製作	川人整合設計工作室
出版者	蔚龍藝術有限公司
	地址：臺北市大同區迪化街一段 127 號
	電話：02-2550-6775
	http://www.bluedragon.com.tw

Organized National Museum of History; Acting Director Chen Teng-Chin
Chihiro Art Museum; Director Tetsuko Kuroyanagi
Blue Dragon Art Company; General Manager Wang Yuling

Assisted Greenland Creative Co., Ltd, The Society of Children's Book Writers and IllustratorsTaiwan,
Common Wealth Parenting, The Graduate Institute of Children's Literature of National Taitung University

Media Assisted SETN, Indulge Esthetics, FunDesign

Exhibition Curators Fumiko Uejima, Michiko Matsukata
Exhibition Team Chihiro Art Museum: Yuko Takesako, Fumiko Uejima, Michiko Matsukata
National Museum of History: Chiang Kuei-Chen, Lin Juei-Tang, Wu Chao-Chieh
Blue Dragon Art Company: Wang Yu-Ling, Cheng Ju-Fang, Wu Hsuan-Yi, Chen Chih-Fang, Chao Man-Chun,
Mao Jui-Sin, Lee Hung-Yi, Lin Lu-Chia, Wang Yu-Chieh
Publisher Wang Yu-Ling
Text Contributors Fumiko Uejima, Megumi Harashima, Michiko Matsukata
Academic Consultant Yu Pei-Yun
Chinese Editing Cheng Ju-Fang, Wu Hsuan-Yi, Mao Rei-Shin, Lee Hung-Yi
Catalogue Design Kawato Design

Publisher Blue Dragon Art Company
No.127, Sec.1, Dihua Street, Taipei, Taiwan
TEL: (02)2550-6775
Website: www.bluedragon.com.tw

出版日期：中華民國 107 年 1 月 31 日
定價：新臺幣 1000 元
ISBN：978-986-95976-1-6
圖版授權：知弘美術館

Publishing Date: 31st January 2018
Price: NTD$1000
ISBN：978-986-95976-1-6
Copyright Credit: Chihiro Art Museum